BASEBALL
IN
BUFFALO

James "Jimmy" D. Griffin was the mayor of Buffalo from 1978 to 1993. He assisted in the effort to bring back baseball to Buffalo in 1979 after almost a decade's hiatus. Bringing a team to Buffalo required $90,000, and 90 investors were raised to donate $1,000 each, including Mayor Jimmy Griffin. (Author's collection.)

FRONT COVER: Perhaps no player has been more loved in Buffalo baseball history than Luke Easter. (Courtesy of the Joe Overfield Collection, the Buffalo History Museum.)

COVER BACKGROUND: "The Giants win the Pennant! The Giants win the Pennant!" New York Giant Bobby Thomson signs autographs for fans in War Memorial Stadium. (Courtesy of the *Buffalo News* Collection, the Buffalo History Museum.)

BACK COVER: The 1887 Buffalo Bisons are pictured with early African American baseball player Frank Grant. (Courtesy of the Buffalo History Museum.)

BASEBALL
IN
BUFFALO

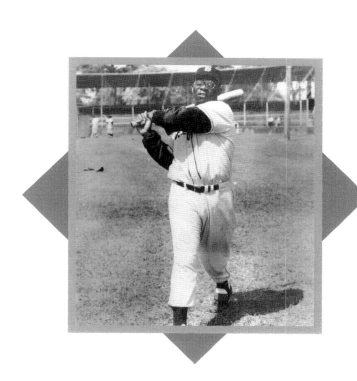

Paul Langendorfer and
the Buffalo History Museum
Foreword by John Boutet

ARCADIA
PUBLISHING

Published by Arcadia Publishing
Charleston, South Carolina

Printed in the United States of America

Library of Congress Control Number: 2016952054

For all general information, please contact Arcadia Publishing:
Telephone 843-853-2070
Fax 843-853-0044
E-mail sales@arcadiapublishing.com
For customer service and orders:
Toll-Free 1-888-313-2665

Visit us on the Internet at www.arcadiapublishing.com

For my mother and father.

"Baseball was, is and always will be to me the best game in the world."
—Babe Ruth

CONTENTS

FOREWORD

The one constant through all the years, Ray, has been baseball. America has rolled
by like an army of steamrollers. It's been erased like a blackboard, rebuilt, and
erased again. But baseball has marked the time. This field, this game is a part of
our past, Ray. It reminds us of all that once was good, and it could be again.
—James Earl Jones to Kevin Costner
Field of Dreams, 1989

This is one of my favorite movie quotes, and James could very well have been talking about Buffalo. Buffalo was once great, had its tough times, and is now on the path to greatness once again. When I list all of the things in this world that I love, the first two that come to mind after my family are baseball and Buffalo. Baseball was a part of my life even before I was born. My father, Paul, grew up in the era when every kid had a glove, and every day there was a game going on. It's all that kids of his generation thought about. Sure, sometimes they played other sports, but there was no debate about which sport ruled the land, it was baseball . . . by a mile. My father passed his love of the game on to me. It's the reason I am who I am today. It's my passion; baseball, Buffalo, and the history they share. Baseball was and still is America's game. It's the sport that truly belongs to us, as it is the oldest American sport. My good friend and *Buffalo News* baseball columnist Mike Harrington wrote an article four years ago entitled "Baseball Still Matters to America, Big Time." In it he wrote "Baseball has been there since before the turn of the century—the last century. Through prosperity and depression. War and Peace. Through triumph and tragedy. When we've needed it most, Baseball has been there."

If you want to understand why baseball is so important, go watch the Ken Burns documentary *Baseball*. You'll understand. The late great Detroit Tigers broadcaster Ernie Harwell wrote: "Baseball, as simple as a bat and a ball, and yet as complex as the American spirit it symbolizes. It's a sport, a business and sometimes almost a religion. Willie Mays making a brilliant World Series catch and then dashing off to play stickball in the street with his teenage pals. That's baseball. So is the husky voice of a doomed Lou Gehrig saying 'I consider myself the luckiest man on the face of the Earth.' This is a game for America, this baseball."

Baseball is the most important and beloved game in Buffalo's long history. Grab a bag of peanuts or maybe a box of Cracker Jack and enjoy the look back . . . play ball!

—John Boutet
Archivist and Curator
AAA Buffalo Bisons

ACKNOWLEDGMENTS

This book has been a labor of love and a journey into the past. I remember fondly the games my dad took me to as a child in War Memorial Stadium, Cleveland's Municipal Stadium, and Pilot Field (now Coca-Cola Field). He taught me how to keep score, something I still do. Talking with my dad about the ballparks of the past, like Offermann Stadium, and what watching games there with his father was like brought this book to life. To everyone listed, I want to express the greatest gratitude for making this work a reality. To my wife, Georgi, this book is as much yours as mine. My scanner, editor, and confidante, she now knows way too much about this subject. ("Alex, I'll take Buffalo Baseball for $600.") Thanks to my son, Jake, for scanning help, and my daughter, Brooke, the "layout specialist." Thanks to my folks for instilling the love of history and baseball in me and for believing in me. Thanks to Cynthia Van Ness, Amy Miller, and Rob de Guehery of the Buffalo History Museum. Cynthia and Amy, thanks for your endless help, knowledge, advice, and patience; Rob, for your chats and daily warm welcomes. To John and Susanna Boutet, thank you for opening your home to us. John, your collection is amazing and I appreciate your letting me share it with the world; your generosity and passion know no bounds. To Dan DiLandro and Linda Webster of Buffalo State, thanks for access to the archives and your quick turnaround. To Liz Gurley, my editor at Arcadia Publishing, you have been incredible with your feedback, input, and availability for all of my questions. Thanks to Roger "Digger" Haddix for helping the idea take root, to all my other Denver and Rio Grande Reds teammates, and to the Colorado Vintage Base Ball Association as a whole. Thanks to Scott Welsh for asking daily about the book writing and being like a brother to me. Thanks to my Denver Help Desk teammates for putting up with the baseball book writing talk and especially to David Hinds for understanding work/life balance. I apologize to anyone I may have missed; you know who you are and you have my appreciation. Last but not least, thanks to the late Joseph Overfield, without whose photograph collection none of this would have been possible. All photographs in this book come from the Joseph Overfield Collection of the Buffalo History Museum unless otherwise noted.

—Paul "Yank" Langendorfer

INTRODUCTION

When he was inducted into the Buffalo Baseball Hall of Fame in 1994, Joseph "Joe" Overfield remarked, "Baseball has always been my life. It hasn't been my living, but it's been so important to me."

Born in 1916, Joe graduated in 1934 from Lafayette High School, where he played second base on the baseball team. At the former Buffalo Collegiate Center, he earned a two-year certificate. He also took evening courses at the University at Buffalo. Joe served in the Army Air Force during World War II, stationed in India as a weatherman.

His career was with Monroe Abstract and Title Corporation (known today as Monroe Title), where he was hired in 1937 as a title searcher. He retired in 1983 as vice president and head of the Buffalo office.

Joe's research passion began after he left the Army and returned to his job at Monroe Abstract and Title. While doing title searching in Erie County Hall, Joe recalled that he came across "a report on the financial condition of the 1878 Buffalo baseball team. That got me started on looking up information on that team. It just kept going from there."

The rest of us benefited greatly from Joe's lifelong devotion. When he published *The 100 Seasons of Buffalo Baseball* in 1985, it was the first book-length history of professional baseball in Buffalo. It is now out of print and has become a prized collector's item. Libraries as far away as Utah and California have copies in their collection. It is our go-to book for answering Buffalo baseball history questions.

Overfield's baseball scholarship began in 1953, when he contributed his first article to the *Buffalo Evening News*. Over the years, he published articles in local newspapers, the *Sporting News*, *Baseball Digest*, the *Research Journal of the Society of American Baseball Research*, and Buffalo Bison baseball club publications. He assisted with revisions of the *Official Encyclopedia of Baseball* and helped research *Minor League Baseball Stars* (1978). Joe is one of the many people credited by Ken Burns for his pioneering *Baseball* documentary television series (1994).

We began publishing Joe's work in 1954 in *Niagara Frontier*, a quarterly journal that the Buffalo History Museum, then called the Buffalo Historical Society, issued from 1953 to 1982. Volume 1 includes an Overfield article, "Professional Baseball in Buffalo."

From 1956 to 1961, Joe served as a director and secretary of the Bisons. He was also an advocate for his beloved team. Thanks to Joe's work, Buffalo Bison pitcher James "Pud" Galvin (1856–1902) was inducted into the National Baseball Hall of Fame in 1965.

In 1994, we honored him at the Buffalo History Museum (at that time we were known as the Buffalo and Erie County Historical Society) with our Augspurger award, which is presented to an individual for outstanding service to the cause of local history.

Joe was a thorough collector. Sports journalist Pete Weber called Joe's home "the Cooperstown of Buffalo baseball." A large picture of the now-demolished Offermann Stadium on East Ferry Street hung over the family mantelpiece.

After Joe died in 2000, his son, Dr. James "Jim" Overfield, donated Joe's papers to the Buffalo History Museum, where they were processed and added to the manuscript collections in the research library. Today they fill 22 archival boxes, or about 10 linear feet of photographs, letters, and other memorabilia.

According to Buffalo baseball historian Howard Henry, who volunteered with us to work on the Overfield collection and wrote the inventory for it, highlights include a team photograph of the National League ball club (Bisons) of 1879, a team photograph of Buffalo's Federal League ball club (Buffeds/Buffalo Blues) of 1914–1915, the Players League Bisons of 1890, Buffalo's flirtation with major-league expansion (the Continental League) and later efforts in the 1990s, Buffalo baseball stadium photographs from 1878 to the present, and articles on hall of famers from Buffalo who played for the Bisons.

Joe occasionally departed from baseball history to do other research. In 1960, for its 150th anniversary, he published a history of the Buffalo Baptist Association. In 1981, he published a booklet on the *Hudson*, a steamer that sank in Lake Superior in 1901. In 1992, he published a volume of Civil War letters written by his ancestor, George Parks, who served with the 24th Cavalry. All of these titles are available in the research library.

The Overfield collection augments other significant archival baseball material in the research library. We have the Niagara Base Ball Club account and game books from 1857 to 1861, plus its constitution and by-laws, a small booklet published in 1867. The Niagaras were Buffalo's first team. We still get out their original ledgers for researchers. We understood early on that baseball was integral to the fabric of Buffalo's social and recreational history.

Other baseball scholars whose work we have are Kevin Grzymala, who published articles about African Americans and German Americans in Buffalo baseball, and Frank Overmeyer, who published an article on Frank Grant. Grant, who was African American, was a second baseman with the Bisons. He integrated Buffalo professional baseball in 1886, sixty years before Jackie Robinson. We still collect baseball memorabilia: the modern Buffalo Bisons are represented in the collection by media guides, programs, magazines, schedules, and photographs.

Today, through the work of Paul Langendorfer, some of the most captivating or rarely seen images from Joe's collection have been reprinted in this book. The Buffalo History Museum is delighted to be a part of this publishing project and to offer this remembrance of our legendary baseball historian and collector.

No appointments are necessary to use the Joseph Overfield Collection, though researchers must register their names and addresses with us and present a valid photo ID. Readers who want to know what else we have on baseball (or any other) history can search FRANK, our online catalog, at opac.libraryworld.com/opac/home. Library hours are Wednesday through Saturday, 1:00–5:00 p.m., with additional Wednesday evening hours from 6:00–8:00 p.m. starting in 2017.

THE STADIUMS

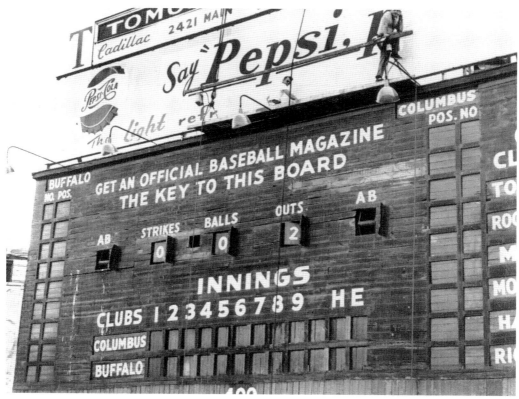

The wood and metal scoreboard of Offermann Stadium is shown in this undated photograph. The scoreboard was hand-operated and changed with each game. The workers at the top of the photograph appear to be changing out the advertisement that graced the scoreboard and all outfield walls. The signage on top of the Pepsi ad is for Tinney Cadillac, which opened its doors in 1954 and was located at 2421 Main Street in Buffalo in the location of the former Buffalo-built Pierce-Arrow Motors main showroom.

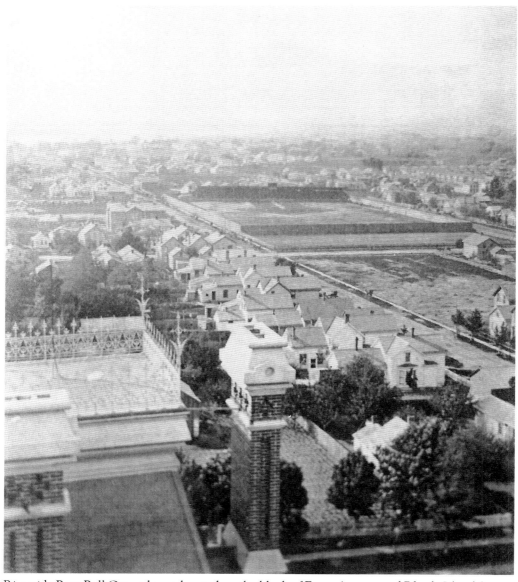

Riverside Base Ball Grounds was located on the block of Fargo Avenue and Rhode Island Street. The Buffalo Bisons called this park home from 1879 to 1883. In their first season here, they won the pennant in the International Association with a record of 81-32, along with three ties. This view was taken from the Tourists Hotel and was part of a stereoscopic image, a format that was very popular at the time. It took two almost identical images, and when viewed with a stereoscopic viewer, gave the image the appearance of three dimensions. (From the John Boutet Collection.)

THE STADIUMS

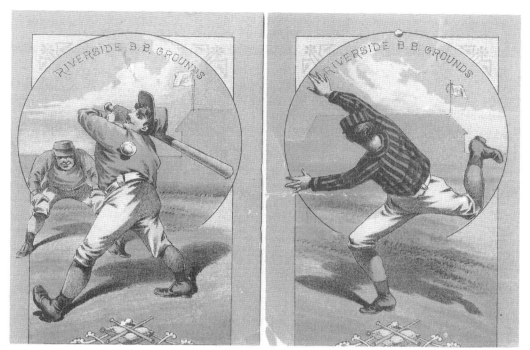

These scorecards sold at Riverside Base Ball Grounds are from 1879 and feature great artwork typical of the period. (From the John Boutet Collection.)

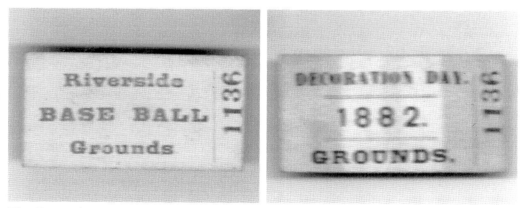

This Riverside Base Ball Grounds ticket stub is from Decoration Day 1882. Decoration Day would first become known as Memorial Day this same year. It was not commonly called Memorial Day until after World War II and was not named officially as such until 1967. (Both, from the John Boutet Collection.)

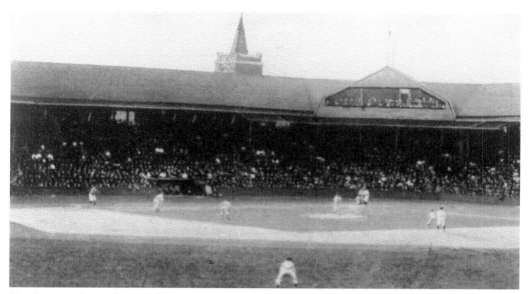

On this site, located at Michigan Avenue and East Ferry Street, baseball was played from 1889 to 1960. From 1889 to 1907, this stadium was called Olympic Park. Lumber from the original Riverside baseball park at Richmond Avenue and Summer Street was brought to this site via horse. In 1907, the name changed to Buffalo Base Ball Park, which it was called until 1923, when it was rebuilt from a wooden structure to a wood and steel edifice and renamed Bison Stadium. Later, it became Offermann Stadium.

In this undated photograph, spectators ring the outfield playing surface of Olympic Park. In the early days of baseball, fans were allowed to stand in the field of play on the outfield grass during the game. The crowds at early games were so large that this was used to pack more paying customers into the stadium. (From the John Boutet Collection.)

THE STADIUMS

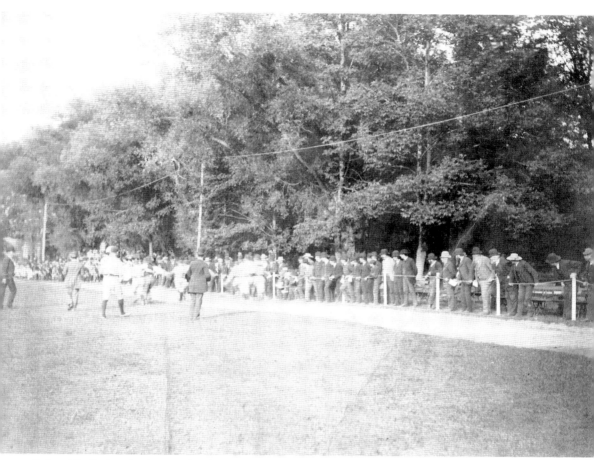

Schwabl's Park, which was also known as Forest Grove Park, was on the outskirts of Buffalo proper in what is now Cheektowaga. It was south of Genesee Street on Pine Ridge Road. Most games played here were on Sundays, as many other municipalities had restrictions on playing baseball on that day. This park was used from 1900 to 1903 and again in 1918. (From the John Boutet Collection.)

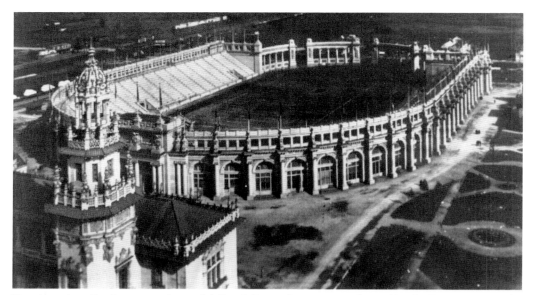

Pan American Stadium was a beautiful Greek Revival structure only used by the Bisons in 1901 for two games, after which the field was deemed not suitable for baseball. The stadium was modeled after the Panathenaic Stadium in Athens, Greece, and was built for Buffalo's Pan-American Exposition, a world's fair held in Buffalo from May 1 to November 2, 1901. The Pan-American Exposition today is unfortunately infamous for the assassination of Pres. William McKinley on September 6, 1901, by Leon Czolgosz. The stadium was torn down along with most of the other Pan-American buildings, the only surviving structure being the Buffalo History Museum.

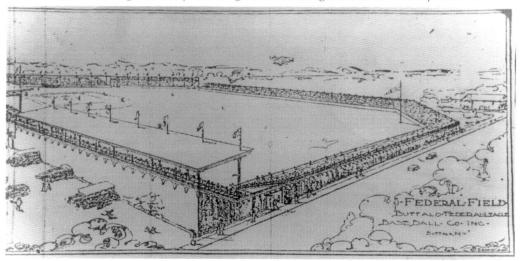

Federal Field was home of Buffalo's Federal League entry, the Buffalo Blues. The field was located on Northland Avenue at Lonsdale Road. The short-lived Federal League was only in existence from 1914 to 1915 and was designed to compete with the established American and National Leagues. The league folded after 1915, when half of its ownership was bought out (including Buffalo) by American and National League owners.

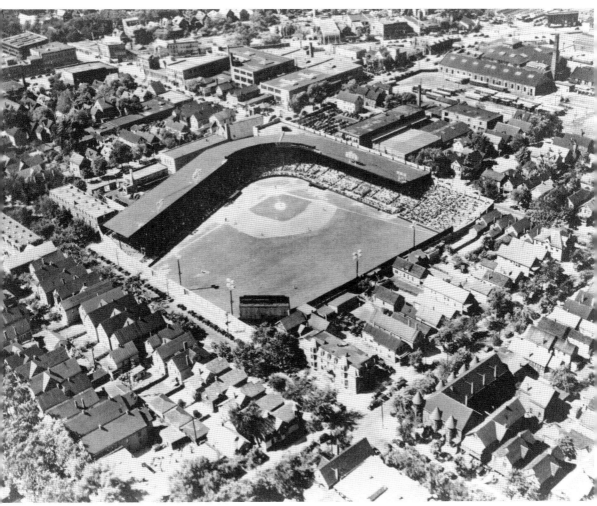

In this undated aerial view of Offermann Stadium, the location of the park on Buffalo's East Side and the close proximity of the houses can be seen. Directly behind the right field wall was a row of two-family homes on Woodlawn Avenue. Great vantage points were to be had from the upper porches and rooftops, and the errant foul ball or home run would provide a great souvenir for eager Buffalo youngsters lucky enough to live in those homes.

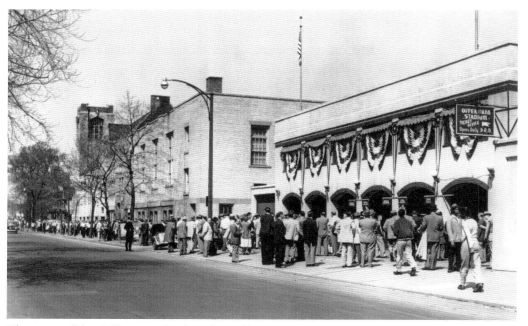

This view of the Offermann Stadium box office was taken from Michigan Street. To the left is the large church that bordered the stadium. It was called Covenant Presbyterian Church at the time of this photograph.

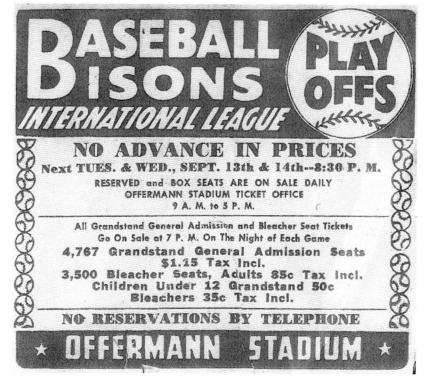

This undated advertisement promotes Bisons playoffs tickets at Offermann Stadium. (From the John Boutet Collection.)

THE STADIUMS

This 1948 photograph illustrates one of Offermann Stadium's best traits: there was not a bad seat in the house. During the 1948 season, the Bisons had a record of 71-80. This season is best remembered for the June 20 double-header versus the Syracuse Chiefs, with the Bisons winning 28-11 in game one. The Bisons hit a league record 10 home runs in that game. In the second game, the Bisons won 16-12, and over the two games combined, the team had 41 hits and 81 at-bats.

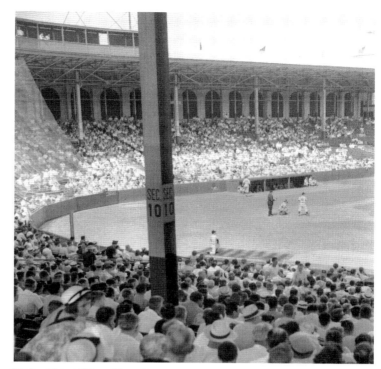

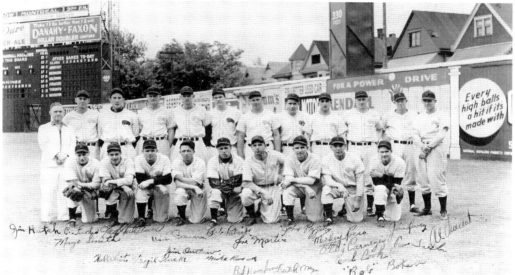

In this photograph taken in Offermann Stadium during the 1941 season, many features of the park are evident. At left is the classic wooden scoreboard. Along the outfield walls is the signage that graced many ballparks of this era. Of interest is the sign on the right of the scoreboard for Danahy-Faxon, which was a supermarket and warehouse on the site of the Broadway Market at Broadway and Bailey Avenue in East Buffalo. Like many early stadiums, the ballpark was located in a neighborhood with homes backing up to the outfield walls. (From the John Boutet Collection.)

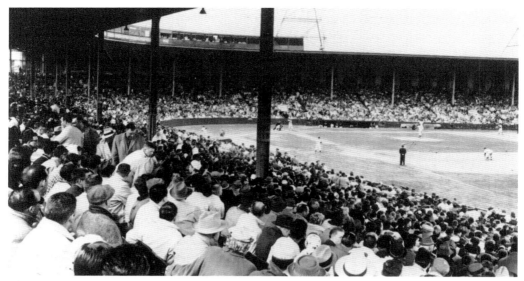

This was Offermann Stadium's last opening day, April 27, 1960, versus Richmond. Opening day was a joyous occasion for all of Buffalo, with a holiday atmosphere that included parades and the closing of schools. From the first to the last opening day and every day in between, Buffalonians loved their team and loved to cheer on their Bisons, sometimes even into the great beyond. One Woodlawn Avenue resident used to love watching the Bisons from his front porch. As he lay in his final state in the front of his house, a home run from the bat of Buzz Arlett broke his front window and came to rest a few feet from his casket. It is not known if the ball traveled to the grave with him.

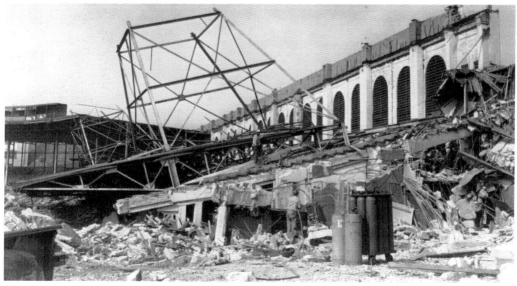

In 1962, after 72 years of Buffalo baseball at the corner of Michigan Avenue and Ferry Street, Offermann Stadium was demolished. The land was needed for the new Woodlawn Junior High School (later Buffalo Traditional School). In 2012, John Boutet spearheaded a group that placed a commemorative plaque on the site on which so many baseball games had been played.

The author (left) and John Boutet pose in front of the Offermann Stadium plaque, all that remains after almost three quarters of a century of baseball on the grounds. (Author's collection.)

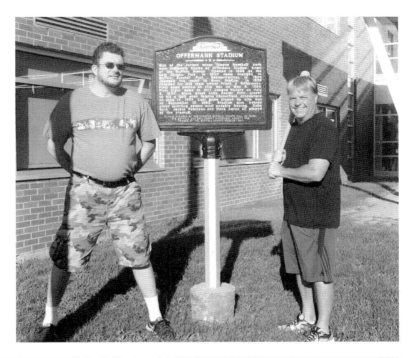

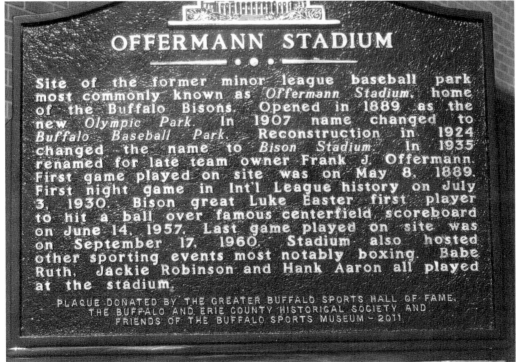

OFFERMANN STADIUM

Site of the former minor league baseball park most commonly known as *Offermann Stadium*, home of the Buffalo Bisons. Opened in 1889 as the new *Olympic Park*. In 1907 name changed to *Buffalo Baseball Park*. Reconstruction in 1924 changed the name to *Bison Stadium*. In 1935 renamed for late team owner Frank J. Offermann. First game played on site was on May 8, 1889. First night game in Int'l League history on July 3, 1930. Bison great Luke Easter first player to hit a ball over famous centerfield scoreboard on June 14, 1957. Last game played on site was on September 17, 1960. Stadium also hosted other sporting events most notably boxing. Babe Ruth, Jackie Robinson and Hank Aaron all played at the stadium.

PLAQUE DONATED BY THE GREATER BUFFALO SPORTS HALL OF FAME, THE BUFFALO AND ERIE COUNTY HISTORICAL SOCIETY AND FRIENDS OF THE BUFFALO SPORTS MUSEUM – 2011

A close-up shows the Offermann Stadium plaque on the grounds of the Buffalo Academy for Visual and Performing Arts. This plaque was dedicated in 2012. (Author's collection.)

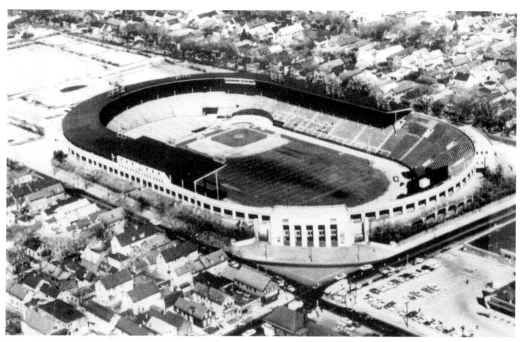

In 1961, the Buffalo Bisons moved to War Memorial Stadium. Constructed in 1937 as a WPA project, the multiuse facility also hosted the AFL and NFL's Buffalo Bills from 1960 to 1972 as well as Canisius College baseball and football teams. In this aerial view, the baseball field and football lines are clearly defined. Its main entrance was off Jefferson Avenue, and the neighborhood stadium was also bordered by Best Street and Masten Park.

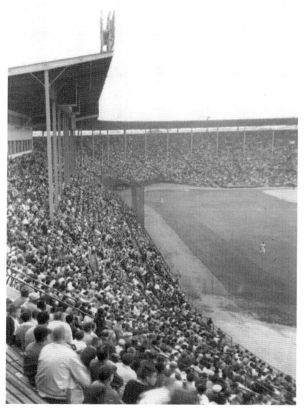

This undated photograph of War Memorial Stadium was taken from the center field stands looking toward home plate. In the foreground is the outfield fence, which ended the confines of the baseball park. The unorthodox layout of the stadium, with a southeast alignment from home plate to center field, provided for many odd and interesting viewing angles.

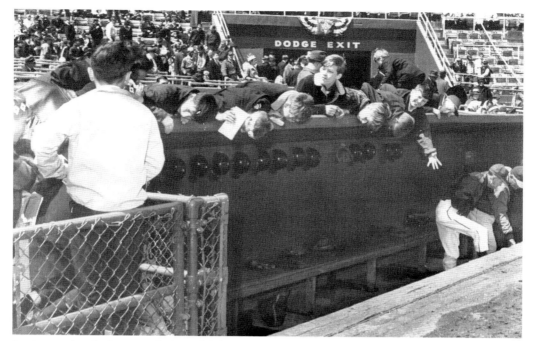

In this undated photograph, hopeful fans at War Memorial Stadium lean into the third-base dugout behind the Dodge Street exit in hopes of autographs from players.

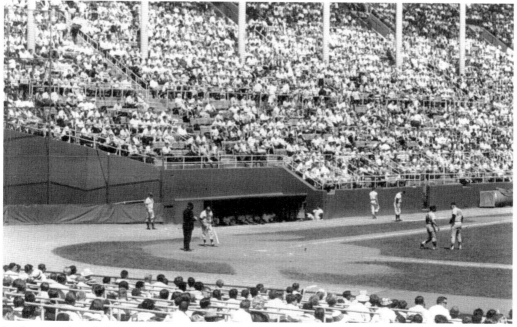

In this view from behind home plate at War Memorial Stadium, the classic support beams holding the roof can be seen. These were a hallmark of the stadium and provided the "obstructed view" seating common to most stadiums of the era. Also notice the rails separating each row of seats.

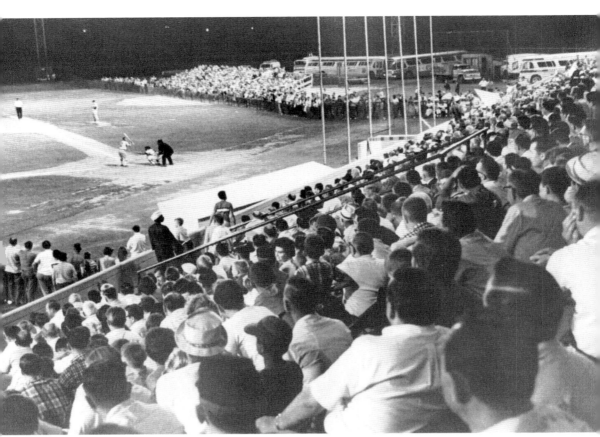

From their beginnings in 1951, Babe Ruth Leagues have been a driving force of youth baseball. Pictured here is a night game of the LaSalle Babe Ruth League at Hyde Park Field in Niagara Falls, New York. During the late 1960s and for part of the 1970 season, the Bisons played their home games in this stadium due to declining crowds at War Memorial Stadium. Hyde Park Stadium has since been renamed Sal Maglie Stadium after the iconic pitcher born and raised in Niagara Falls. (Courtesy of the Buffalo History Museum.)

THE STADIUMS

With Robert Redford playing the main character of Roy Hobbs, Hollywood came to Buffalo in 1983. Looking for a turn-of-the-century stadium to film *The Natural*, which was set in Chicago in the early 1920s, producers settled on Buffalo's War Memorial Stadium. All of the baseball scenes were filmed at the stadium except for one that used Buffalo's All-High Stadium as a stand-in for Wrigley Field. (Courtesy of the *Buffalo News* Collection, the Buffalo History Museum.)

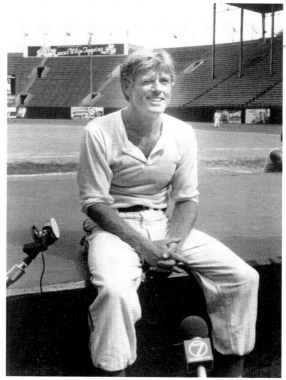

Robert Redford is dressed in his New York Knights uniform as Roy Hobbs, and his costar Glenn Close as Iris is dressed in period attire. In the background, another actor is dressed in the uniform of the Chicago Cubs. Much of *The Natural* was shot in Buffalo at War Memorial Stadium. (From the John Boutet Collection.)

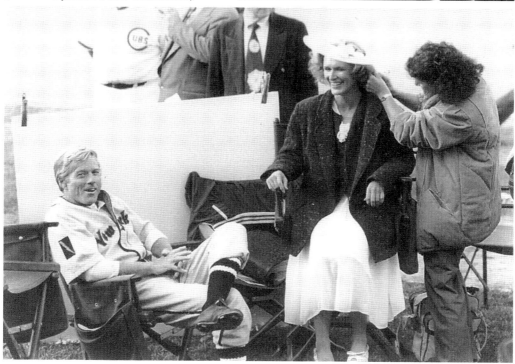

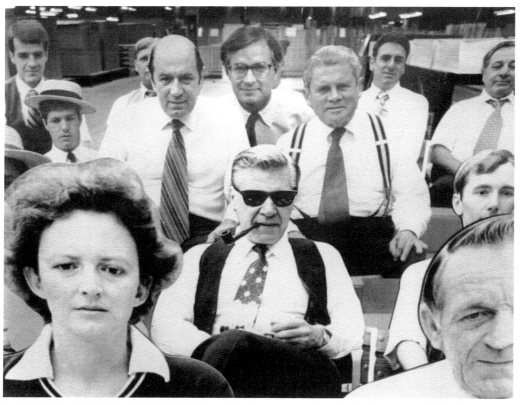

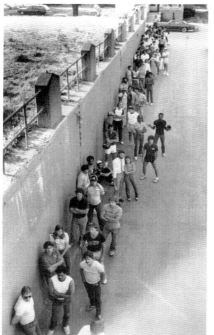

Which one is real and which is not? C. Taylor Kew, center, sits surrounded by cardboard cutouts of the "fans" that would occupy War Memorial Stadium for the filming of *The Natural*. His company, F.N. Burt Co., made the cardboard cutouts for the movie. (Courtesy of the *Buffalo News* Collection, the Buffalo History Museum.)

Hoping to be cast, this line stretched around War Memorial Stadium. Citizens of Buffalo provided most of the extras for *The Natural*. Many were used as crowd filler to line the seats of the stadium. (Courtesy of the *Buffalo News* Collection, the Buffalo History Museum.)

THE STADIUMS

Production for the day sets up under the iconic sign for Parkside Candies. Parkside Candies has been in business in Buffalo since 1927. The store seen here is located downtown off Main Street and is perhaps best known for a Western New York original treat, Sponge Candy. (Courtesy of the *Buffalo News* Collection, the Buffalo History Museum.)

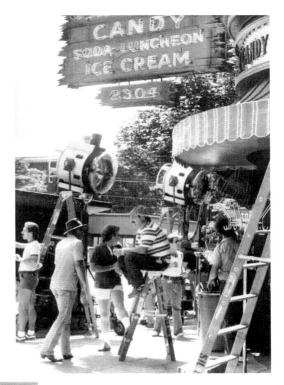

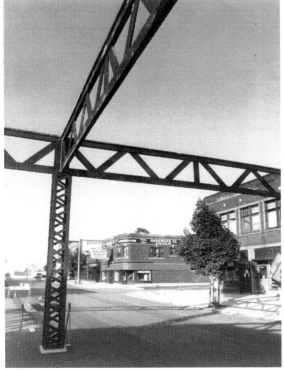

What is real and what is Hollywood? Here, a "fake" bridge spans Main Street in Buffalo. Construction of structures like these helped create the image of Chicago, where part of *The Natural* was set. (Courtesy of the *Buffalo News* Collection, the Buffalo History Museum.)

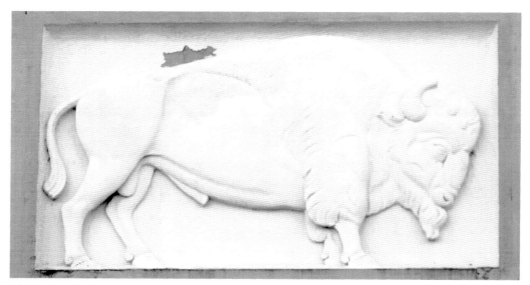

This carved bison frieze can still be found on the exterior walls that remain of War Memorial Stadium. (Author's collection.)

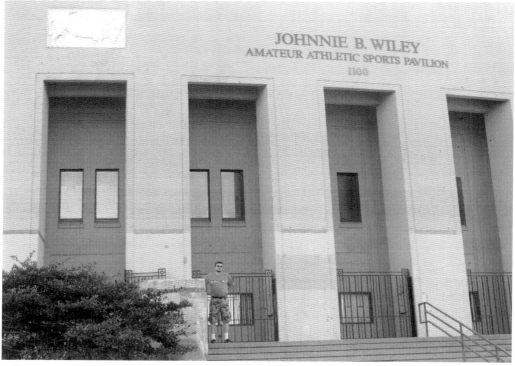

When War Memorial Stadium was demolished in 1988 to build the Jonnie B. Wiley Amateur Athletic Sports Pavilion for area high school sports, two of the original entrances and facades were preserved. Here is the former main entrance on Dodge Street and Jefferson Avenue. This would have been located in the left-field corner of the baseball park. (Author's collection.)

THE EARLY PROS

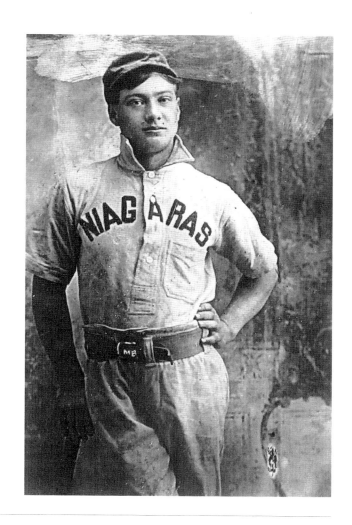

This undated photograph of an unidentified Buffalo Niagaras player shows one of the early uniforms of the team. (From the John Boutet Collection.)

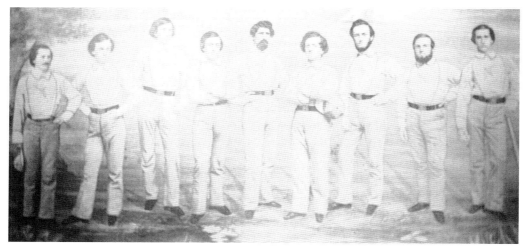

Founded in 1857, the Niagaras of Buffalo were the city's first organized baseball team. This 1859 photograph of the original members was created by pasting individual photos of each player on a backdrop. The team originally played its home games on a field at Seventh and Pennsylvania Streets and later moved to a new field at Main and Virginia Streets with better access. From left to right, the players are William Loomis (left field), Frank Sidway (pitcher), Albert W. Bishop (center field), James H. Sidway (right field), John Higgins (second base), John B. Sage (catcher), William J. Miller (first base), William T. Wardwell (third base), and David Burt (shortstop). James Sidway was tragically killed at the age of 25 in the American Hotel fire of 1865 trying to put it out.

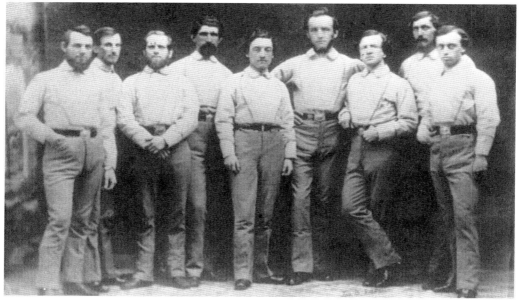

The Niagaras of Buffalo were tied closely to Taylor Hose Company No. 1, the city's first firefighting unit, founded in 1850. Around the Civil War, the club's headquarters were in the firehouse on the west side of Pearl Street. While there, they may have sung a popular song of the day called "The Base Ball Polka," written by club member J. Randolph Blodgett.

This 1865 photograph shows Buffalo's first firefighting unit, Taylor Hose Company No. 1. Firefighters stand in front of their firehouse with their fire wagon. Many members of Taylor Hose Company were also members of Buffalo's first baseball nine, the Niagaras of Buffalo. (Courtesy of the Buffalo History Museum.)

Starting in June 1861, the Niagaras went on a "leave of absence" that lasted through the Civil War. This photograph appears to be of the postwar Niagaras based on the team members depicted. The Buffalo History Museum retains the original score books and ledgers of the prewar team. Of interest is the refunding of dues noted in the ledger book in 1860–1861 to the members designated "Off to War."

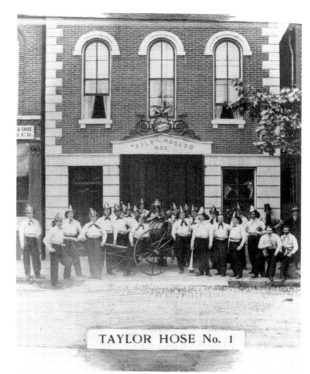

TAYLOR HOSE No. 1

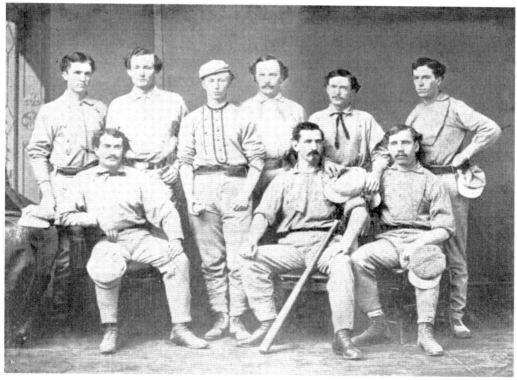

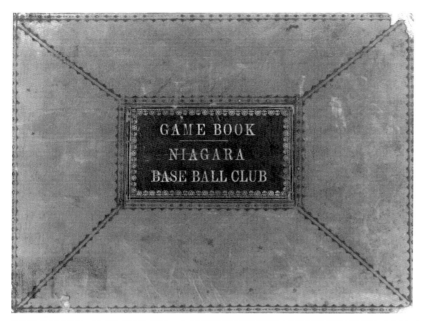

This original bound *Game Book* from the Buffalo Niagaras Base Ball Club includes tallies for each game during the 1857–1858 season. (Courtesy of the Buffalo History Museum.)

On this page of the *Game Book*, the Niagaras' score for Friday, September 11, 1857, can be seen. Unlike a modern score book, only aces (runs) and outs were tallied; on this day, the Niagaras tallied 24 runs. The 1, 2, and 3 in each inning column signifies the first, second, and third outs of the inning. Modern statistics such as RBIs were not calculated; instead, statistics like the aces-to-outs ratio were the flavor of the day. (Courtesy of the Buffalo History Museum.)

THE EARLY PROS

This booklet was published in 1858 by one of the first organized baseball clubs in Buffalo. It contained guidelines for the governance of the club as well as the rules of play. Note the page detail at left; 1858 was the first year that umpires could call strikes on players who would not swing at hittable pitches. The umpire would issue a warning first. (From the John Boutet Collection.)

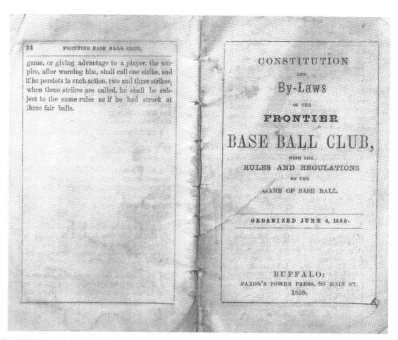

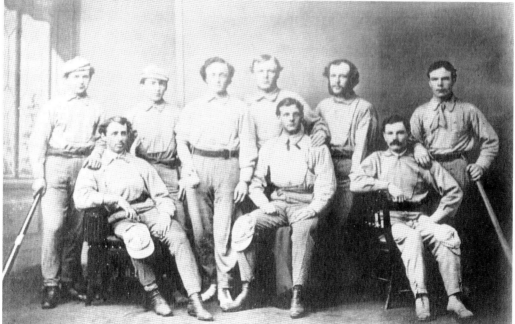

This is the Clifton team, the second professional baseball team in Buffalo. Originating in 1867, they played their games on a vacant lot on Virginia Street. This photograph shows one of their distinguishing features: checkered uniforms. By 1869, the Cliftons had disbanded, and some had become a part of the Niagaras roster for good, thus creating a stronger ball club for Western New York to compete on a regional and national level. (From the John Boutet Collection.)

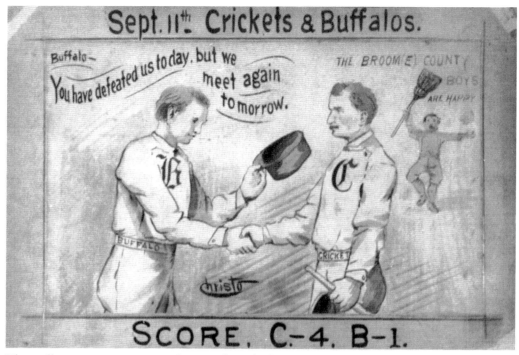

These illustrations were part of a set released after each Buffalo game in 1877 depicting the previous game and its score in a humorous light. The examples here are from the September 11 match versus the Crickets and a match versus the Flour City (Rochester) club on September 24. These were drawn by Buffalo artist Christopher Smith and were displayed in a downtown clothing store. (Both, courtesy of the Buffalo History Museum.)

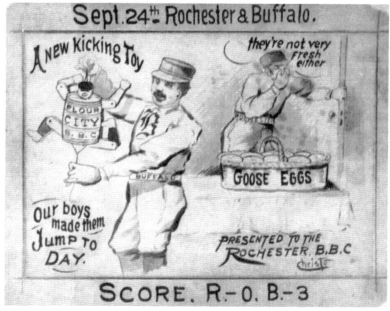

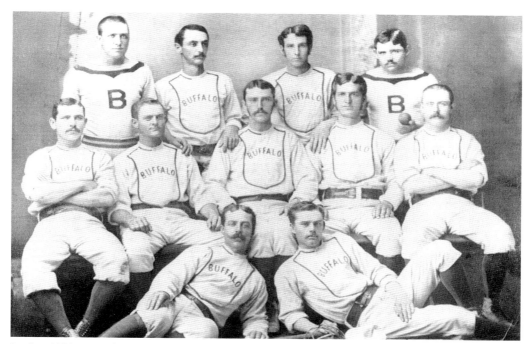

In this 1878 team photograph, one of the greatest Bisons is pictured at top right holding the ball. It was common at the time for the best player on the team to hold the ball in team photos; this player was certainly hall of fame pitcher James F. "Pud" Galvin. From left to right are (first row) David W. Force (captain, shortstop) and John "Trick" McSorley (change player); (second row) William M. Crowley (left field and change), David Eggler (center field), Stephen A. Libby (first base), Chas J. Fulmer (second base), and Dennis McCrohan (right field); (third row) Thomas J. Dolan (catcher), Cyrus A. "Dick" Allen (third base), William "Gunner" McGunnigle (right field), and Galvin. (Courtesy of the Buffalo History Museum.)

"The Big Four" consisted of Dan Brouthers, Hardy Richardson, Deacon White, and Jack Rowe, and played together for eight seasons with Detroit and Buffalo. The *Sporting News* wrote of them: "How the Big Four was admired! Even in hostile cities the fans praised them in the next breath after they had jeered them." Their hitting prowess was unmatched in the league. In 1881, one of their better seasons, they posted the following batting averages: Brouthers, .319 with eight home runs (dead ball era); Richardson, .291; White, .310; and Rowe, .330. Future hall of famer and manager Jim O'Rourke rounded out the offensive outburst that season with a robust .302 average.

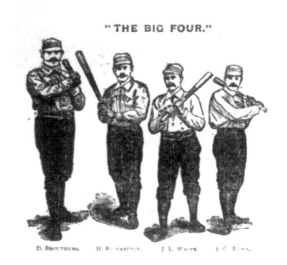

"THE BIG FOUR."

D. Brouthers. H. Richardson. J. L. White. J. C. Rowe.

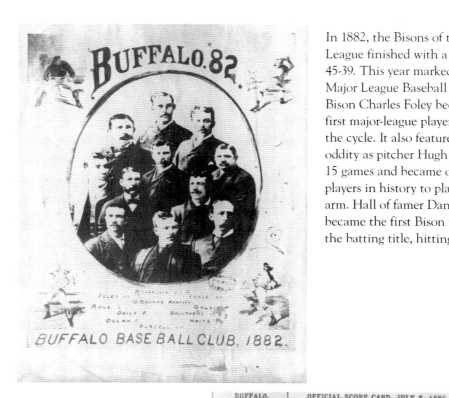

In 1882, the Bisons of the National League finished with a record of 45-39. This year marked a first in Major League Baseball history as Bison Charles Foley became the first major-league player to hit for the cycle. It also featured a baseball oddity as pitcher Hugh Daly won 15 games and became one of two players in history to play with one arm. Hall of famer Dan Brouthers became the first Bison to win the batting title, hitting .368.

BUFFALO BASE BALL CLUB, 1882.

This 1885 scorecard includes all of the members of Buffalo's Big Four, Dan Brouthers, Hardy Richardson, Jack Rowe, and Deacon White. Playing together with Pud Galvin, they became one of the best groups of players assembled at one time. Alas, 1885 was the last year of the Big Four with Buffalo, but it was one of their best. Brouthers hit .359, Richardson .319, White .319, Rowe .290, and Galvin .292. (From the John Boutet Collection.)

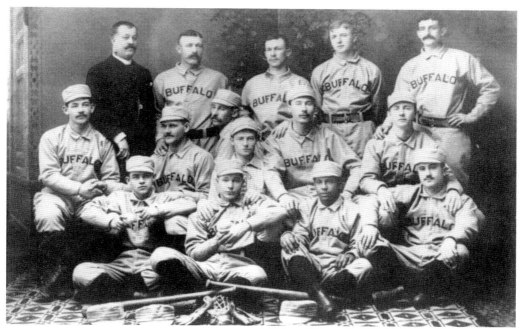

The Buffalo Bisons entered the International League in 1887 and finished with a record of 65-40. This was second baseman Frank Grant's second season with the team. In his first season the prior year, Grant (second from right in first row) broke the color barrier six decades before Jackie Robinson. Grant had a fantastic season in 1887, leading the league in home runs with eight and batting .366. It was an interesting statistical year as well, as this was the only year in baseball history when walks counted as hits. (Courtesy of the Buffalo History Museum.)

Frank Grant, seen here in a Cuban Giants uniform, played three seasons with Buffalo from 1886 to 1888. Arguably the first African American ballplayer, he excelled on the diamond and at bat. In 1886, he batted .344, in 1887 he averaged .366, and in his last season as a Bison he hit .331. A second baseman for two of his three years in Buffalo, in 1888 he moved to right field as his defense lapsed, which may have been caused by increased racial pressure. In 1888, there was a motion in the league to ban all black players. This would be Frank Grant's last year in baseball, and it would be almost three quarters of a century before African Americans again had a place in white baseball leagues. (Courtesy of the Buffalo History Museum.)

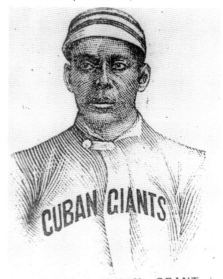

SECOND BASEMAN GRANT-
A Famous Ball Player's Life Story—Three Seasons With Buffalo — Now a "Cuban Giant."

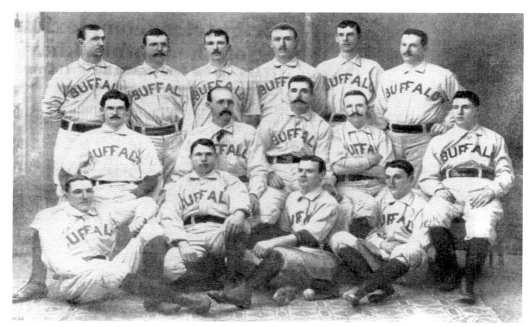

In 1890, the city of Buffalo hosted two baseball clubs. One of them was the Brotherhood team of the Players League. This was a league that was organized and managed by the players. Among the most notable of these Players League individuals was Connie Mack (top row, second from right). This hall of famer would have a profound major-league career as both a player and manager. He managed an amazing 7,679 games with a win-loss record of 3,731-3,948 and World Series championships.

This undated photograph of Buffalo playing Philadelphia (and the two on the facing page) may date to 1890, as this was the year when both teams played in the Players League. It is uncertain where the photographs were taken. (Courtesy of the Buffalo History Museum.)

The Bisons played their home games during the 1890 season in Olympic Park at the corner of East Ferry Street and Michigan Avenue; these pictures may have been taken there. (Both, courtesy of the Buffalo History Museum.)

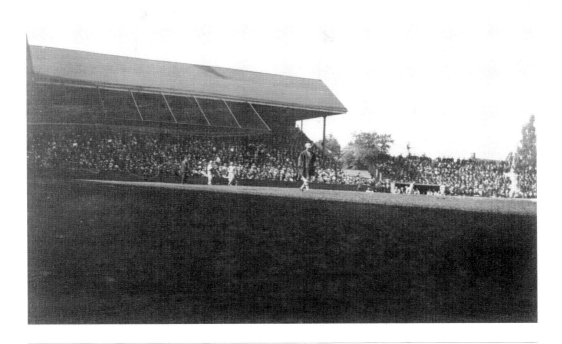

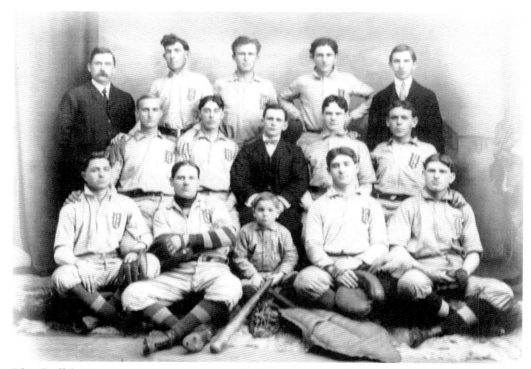

This Buffalo Bisons team poses in the early 20th century. Although the catcher's gear in the foreground may look rudimentary by modern standards, it was high-tech for the time. The first catcher's mask and chest protector were created between 1880 and 1890 and would become staples for the man behind the plate. The boy was likely the team's "mascot," which was an early name for batboys. (From the John Boutet Collection.)

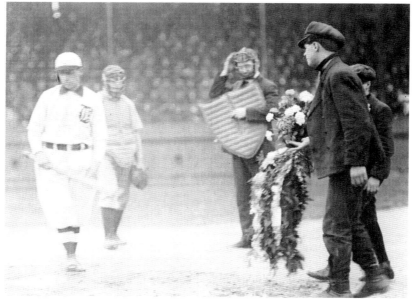

In this c. 1900 photograph, a Buffalo Bison player strolls to the plate. "Luck wreaths" such as the one pictured here were common at the start of a season, but it is not known if this photograph was taken at home or on the road. (From the John Boutet Collection.)

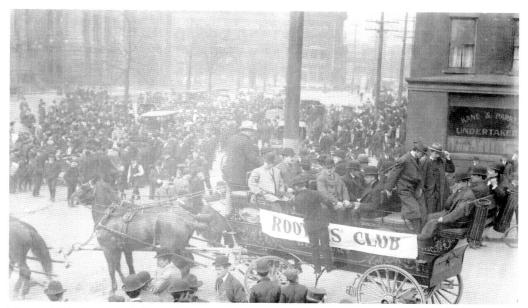

This c. 1900 photograph shows a Buffalo Bisons Rooters Club parade. The parade route took them down Church and Franklin Streets. The undertaker in the background is Kane & Parker at 43 Church Street on the corner of Franklin Street. (From the John Boutet Collection.)

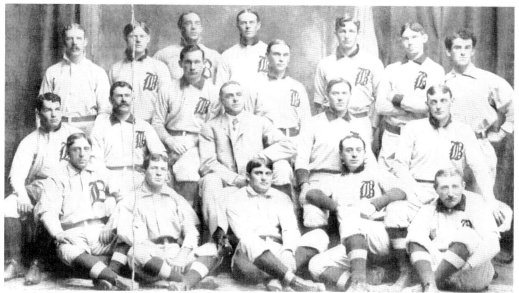

The Buffalo Bisons pose for a team photograph in 1902. This season of Buffalo baseball was the first under longtime manager George Stallings. The team would finish with a record of 88-45 and be in the hunt for the pennant until the final day of the season, not bad for a team constructed by Stallings in a little under three months. Stallings would later manage the 1914 "Miracle Boston Braves" team that won the World Series. This feat would also earn Stallings a new nickname, "The Miracle Man." (From the John Boutet Collection.)

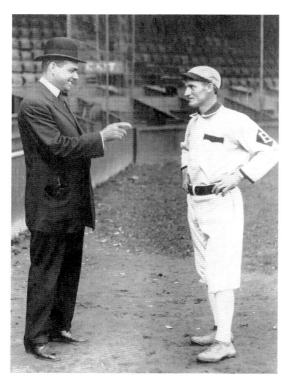

George Stallings is an iconic Bison builder and manager. In January 1902, the Bisons franchise was declared forfeit for failure to pay league dues. The franchise was awarded to George Stallings, manager of the Detroit club in 1901. Rather than moving the team, Stallings went to work and within a little more than two months had accumulated 14 players and built a franchise virtually from the ground up. Here, Stallings shares his wisdom with an unidentified Buffalo player. (From the John Boutet Collection.)

In 1903, the Bisons sported a record of 79-43 and finished second in the league. One of the stars of the team was hometown pitcher Billy Milligan. His record was 21-6, and he was also solid at bat with a .279 average and seven home runs, good for second in the league during the dead ball era. Captain Jake Gettman had a .334 batting average with 120 hits, seven home runs, and 20 stolen bases. Alas, he injured himself sliding into second and did not play after August. This event later became immortalized in a poem.

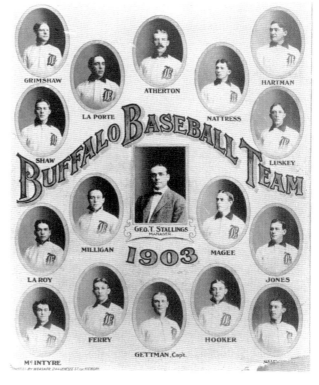

THE EARLY PROS

You may talk of Pat Powers and his Jersey boys,
They're heavy hitters and big for noise,
You may cheer your Hanlon's and whoop McGraws,
But stop for a second, I bid you pause,
While I hit it up for the man who inspires
His faithful nine with invisible wires.
George T. Stallings, THE BEST THERE IS!
An all around sport who knows his "BIZ".

As the season closes, we heave a sigh
To the twirling sphere we say "GOOD BYE"
But only to rest through the winter snows,
Then up she comes and away she goes.
Then a toast to them all, both short and tall,
The Kings of the Bat and Knights of the ball,
Who have held their own with a sturdy pull,
In the face of luck that would stagger a bull.

A toast to them all with might and main,
Including the runaway, Dave L. Brain,
Whose place was filled with a level head
Whom the boys call "Dutch" but the girls call "Fred",
And "Sas Pop" "Cy", a base ball King,
The Children's friend and the *Real Old Thing*.
And to FERRY the tall, the pitcher green,
Who is now dead ripe, with a record clean.

A toast to them all, strong, sturdy men,
And a hearty cheer from old Box 10.
No better friends have the Buffaloes
Than those they find right under their nose.
Right back of the bench of the Buffalo boys,
You can always hear that "Rooting" noise,
They may lose a game and a pennant to boot,
But old box 10 continues to root.

So a final toast to the broken bones,
And to those who have flown to other zones,
May the bones heal up and the boys return,
To the hearts that here, with affection, burn.
And with decent luck and a half a show
We'll have that pennant at Buffalo,
And when she comes, just count on a spread,
With the compliments of
 "Faithful Fred".

Dedicated
to the
Buffalo Baseball Club
by James Clarence Harvey

I sing the song of a deep regret
For a beautiful plan which fate upset
Of a pennant fair that would have been ours
Except for the tricks of the higher "*Powers*."
So the song I sing is softly wailed
In minor key because we failed
And all big Buffalo wails and moans
That you can't play ball with broken bones.

A well groomed lot was the Buffalo Herd
Each man a star and a crack-a-jack bird
They took the lead and they held it well
Though all the other Clubs fought like—well—
They tried their best and the Umpires too
They did as much as they dared to do,
It seemed dead easy to take the cake
When Buffalo bones began to break.

What could we do when gentle Jake
That Center field was forced to forsake?
He could run like a deer, he had no fear
And his swift directions were crisp and clear;
But Jake has a temper and would if he chose
Just revel in busting an Umpire's nose,
'Twas a terrible dreadful blow, no doubt,
When Captain Jake Gettman went down and out.

But even at that we feared nobody
And didn't get scared 'till we lost our Shoddy
Who, back of the bat, could show his power
And the balls like cakes at the breakfast hour
Went into his mitt and what did they do
They seemed to be covered with Spauldings glue,
But a slip and a slide and a horrible plunge
And dear old Shoddy threw up the sponge.

This poem was written for the Buffalo baseball team in 1903. This was a prosperous time for Buffalo baseball, as the Bisons under manager George Stallings and captain Jake Gettman would win two pennants and two Little World Series championships. Unfortunately for the team, as this poem relates, the injury to Jake Gettman cost them the pennant that season. (From the John Boutet Collection.)

This official program is from the 1904 season, which statistically may have been one of the best seasons ever for the team. With a win-loss record of 89-46 and a victory in the Little World Series, they were led by the otherworldly pitcher Rube Kissinger, who had a record of 24-11, and the hitting of first baseman Myron Grimshaw, who hit .325 for the year. (From the John Boutet Collection.)

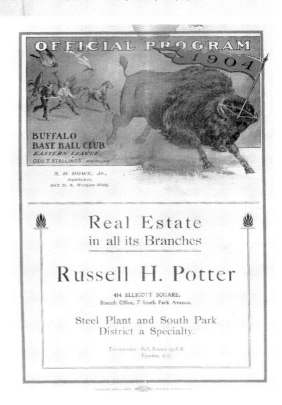

In 1904, the Bisons acquired pitcher Rube Kisinger from Detroit. It would prove to be a great acquisition. Over his Buffalo career, Kisinger won 117 games, pitched a no-hitter, and hurled 10 shutouts in one season (a Buffalo record) and 31 shutouts. His 1904 team won the Little World Series over St. Paul two games to one in a shortened season, backed by his record of 24-11.

This poster-sized photograph commemorates the pennant-winning team of 1906, despite the year listed. Managed by George Stallings, this Buffalo team had a record of 88-55. One of their best hitters was outfielder Jimmy Murray, who led the league with seven home runs—dead-ball baseball at its finest. The pitchers for this team were stellar, with both Rube Kisinger and Lew Brocket winning 23 games and Ralph Tozer pitching 16 wins of his own. This would be George Stallings's last year as manager of the club (although he would return to manage later). In five years, his record was 404 wins and 263 losses.

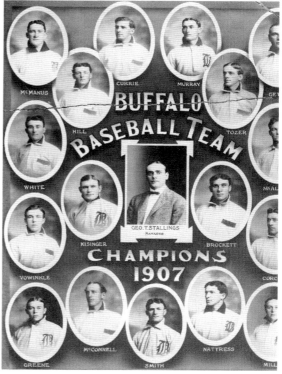

George Stallings managed the Buffalo Bisons for seven seasons at the turn of the 20th century. Posting a record of 549-416 and guiding the team to two pennants and two Little World Series wins, he may be considered one of the most successful managers for the Buffalo Bisons. They captured their first flag under Stallings in 1904 with an 89-46 record and the second in 1906 with an 85-55 record and his second Little World Series title.

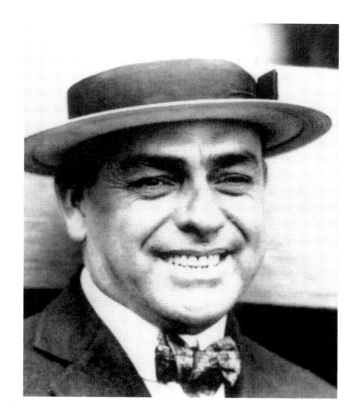

Some early baseball cards came in tins of round chewing gum made by Colgan Gum Company of Louisville, Kentucky. The card seen here is from the 1909–1911 "Stars of the Diamond" collection. The player is Walt Woods, who played in 73 games for the Buffalo franchise in 1910. (From the John Boutet Collection.)

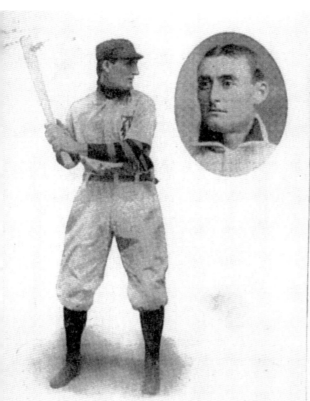

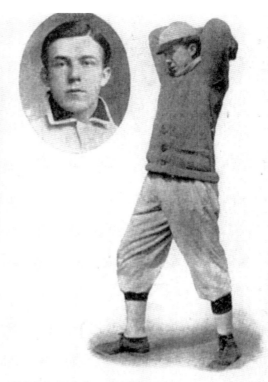

JAMES MURRAY, Right Fielder on the Buffalo Team for 1908

Nickname, Mexico Pete

Years in game, 11 ; Came from Toronto ; Home, Mexico City ; Years with Buffalo, 4 ; Single ; Age, 29 ; Weight, 175 ; Height, 5.11. Averages in 1907 Batting, .272 ; Fielding, .973 ; S. H., 17 ; S. B., 30.

JOHN H. VOWINKLE, Pitcher on Buffalo Team for 1908

Nickname, Rip

Years in game, 6. Came from Utica. Home, Oswego, N. Y. Years with Buffalo, 2. Married. Age, 23. Weight, 190. Height, 5.11. Averages in 1907—Batting, .139. Fielding, .988. S. H., 3. S. B., 1.

Jimmy "Mexico Pete" Murray played for Buffalo for seven seasons. The right fielder had one of his best seasons for the Eastern League Bisons in 1912. He batted .311 and led the team with 15 home runs. Even more impressive is his 24 triples, which set a Buffalo Bisons record that still stands today. His best days would be as a minor-league player, as he would only play three seasons in the major leagues with a .203 average. The other half of this early baseball postcard features John H. "Rip" Vowinkle. This Oswego, New York, native pitched a hefty 304.0 innings and posted a record of 16-16 with a 3.73 ERA in 1909. (From the John Boutet Collection.)

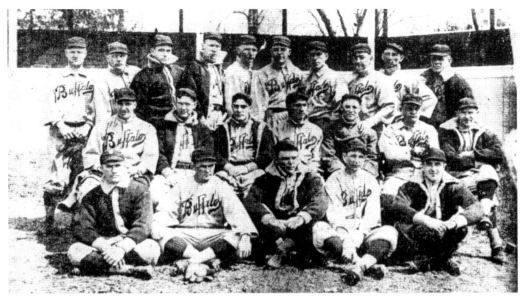

In 1914 and 1915, Buffalo played in the Federal League, a rival to the existing American and National Leagues. Buffalo's entry was nicknamed the "Feds" for 1914 and the "Blues" for 1915. These teams finished 80-71 in 1914 and 74-78 in 1915. One of the standout players in both seasons for Buffalo was first baseman Hal Chase, who came from the American League's Chicago White Stockings despite being under contract to them. Chase had an outstanding two seasons in the Federal League, batting .347 in 1914 and .291 in 1915 with 17 home runs to lead the league.

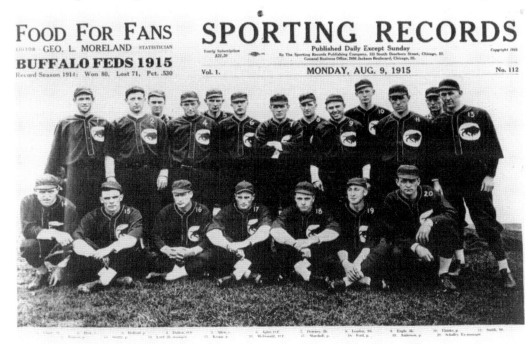

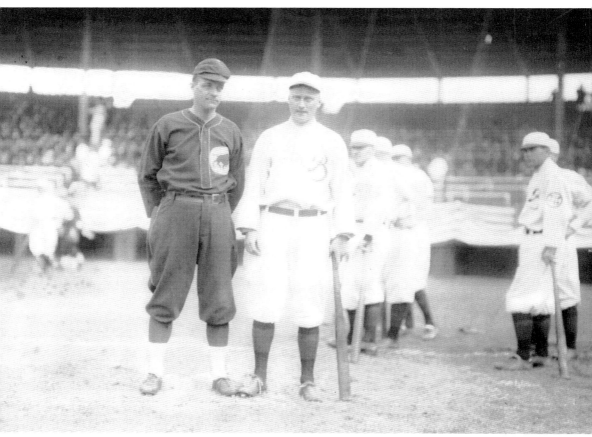

This 1915 photograph shows the Federal League teams for Brooklyn and Buffalo (left). It was taken at Brooklyn's home field of Washington Park. The Buffalo team was nicknamed the "Blues," and the Brooklyn franchise was called "the Tip-Tops," as owner Robert B. Ward owned the Tip Top Bakery. The team displayed its nickname with a patch on the left sleeve. The Buffalo player is manager Larry Schlafly. (From the John Boutet Collection.)

THE EARLY PROS

This image comes from official team stationery for the 1916 Buffalo Bisons. The Bisons were International League champions the previous year. (From the John Boutet Collection.)

These vintage baseball cards of Buffalo Bisons players are from the 1912 Imperial C46 set. They were manufactured in Canada and only made for International League teams. (From the John Boutet Collection.)

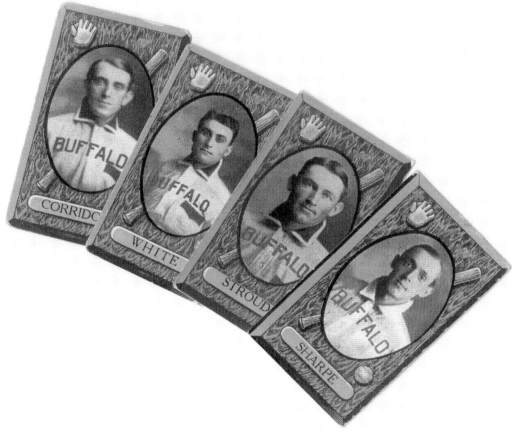

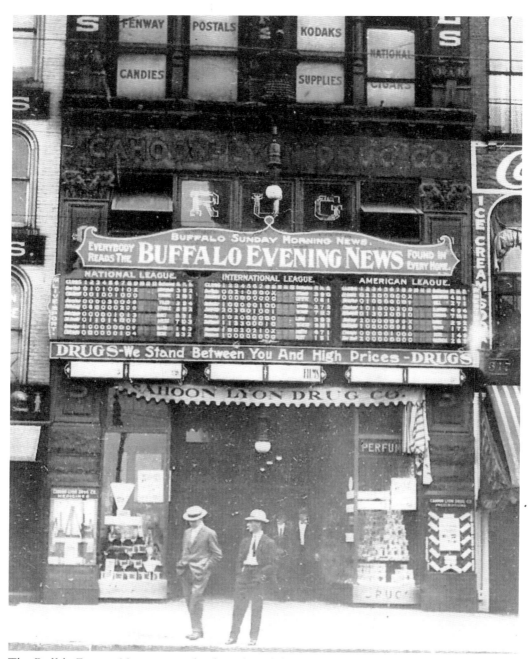

The *Buffalo Evening News* put up this large board that showed the standings for the American, National, and International Leagues. It was located on the Cahoon Lyon Drug Co. store at 319 Main Street. Cahoon Lyon Drugs was one of Buffalo's larger drugstore chains, with five stores. They also boasted of their extensive 28-foot soda fountain at this location. What better way to spend a Saturday afternoon than getting a cool fountain drink and checking out the baseball standings? The photograph is from around 1912. (From the John Boutet Collection.)

THE EARLY PROS

3

GATEWAY TO THE MAJORS

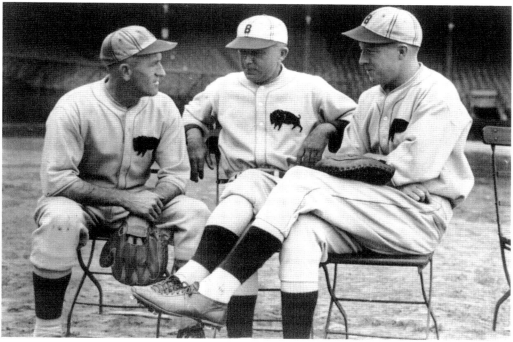

Ray Schalk (center) managed the AA Bisons of the International League for five seasons, from 1932 to 1937. He is pictured with players Buck Crouse (left) and Jack Smith. Schalk led the team to two league titles in 1933 and 1936. In the pennant-winning year of 1933, Crouse was catcher for 109 games, with a .270 batting average. Smith played 160 games at first base and batted .278. Perhaps the most remarkable thing about Ray Schalk is that he played 17 seasons in the major leagues, including on the infamous 1919 Black Sox team, but he was never accused of any wrong doing by the league. He was elected to the hall of fame in 1955, further exonerating him of any wrongdoing in the gambling scandal in the 1919 World Series. During that tainted series, Schalk hit .304 and was one of the whistleblowers, telling officials he thought there may be wrongdoing when Eddie Cicotte and Claude "Lefty" Williams did not throw the pitches he called.

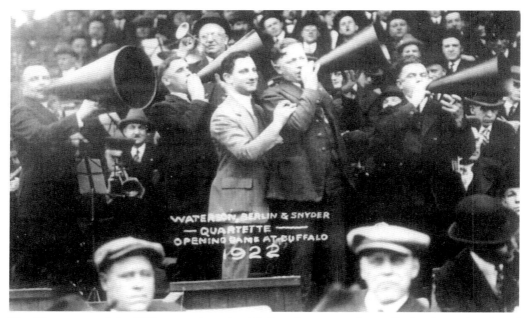

The Bisons started the 1922 season in style with famed composer Irving Berlin (center) on hand for opening day festivities. This season, the Bisons posted a record of 95-72, but finished in third place, 20 games behind the powerhouse Baltimore Orioles. (From the John Boutet Collection.)

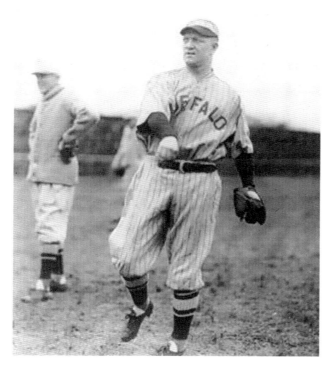

Andy Anderson, sporting the team's classic pinstripe look from the 1920s, had a great season in 1927 as the team won the pennant. Anderson batted .328 with 23 doubles and 105 hits. (From the John Boutet Collection.)

The Bisons wore these pinstripe jerseys in the 1920s. One interesting fact about this jersey is that it did not have any numbers on the back. The first Major League team to use numbers to identify players was the Cleveland Indians in 1929. Both the Indians and Yankees planned to adopt numbering that year, but as the Yankees' first game was rained out, Cleveland won the honor of being the first. (From the John Boutet Collection.)

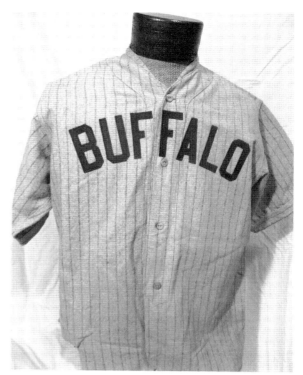

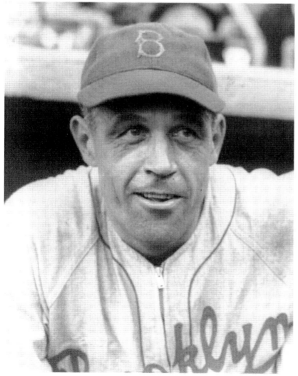

In 1927, no hitter may have had a better year for the Buffalo Bisons than Del Bissonette. He batted .365, scoring 168 runs with 229 hits, 46 doubles, 20 triples, and 31 home runs. So great was Bissonette's season that even publications such as *Baseball* magazine were singing his praises. Witness this verse from writer L.H. Addington: "The Bisons had Del Bissonette / No Meal had he ever missed yet. / The question that rises / Is one that surprises / Who paid for all Del Bisson-ette?"

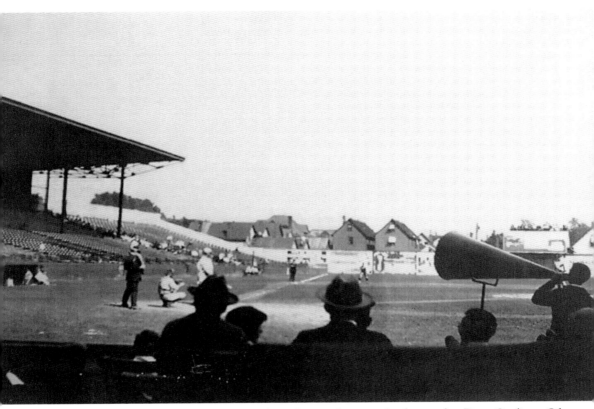

This photograph from 1927 shows a view from the stands across the diamond in Bison Stadium. Of particular interest is the large megaphone that served as the stadium's public address system. This year would be good to the Bisons, as they finished with a record of 112-56, winning the pennant but unfortunately losing the Little World Series. (From the John Boutet Collection.)

These two ticket stubs were used at Offerman/Bison Stadium for entrance to the grounds. The top stub is from September 5, 1935. The one at right is from the 1927 Little World Series versus the Toledo Mud Hens. (From the John Boutet Collection.)

The Bisons wore this block print jersey for most of the 1930s, as seen in the 1932 team photograph on the next page. (From the John Boutet Collection.)

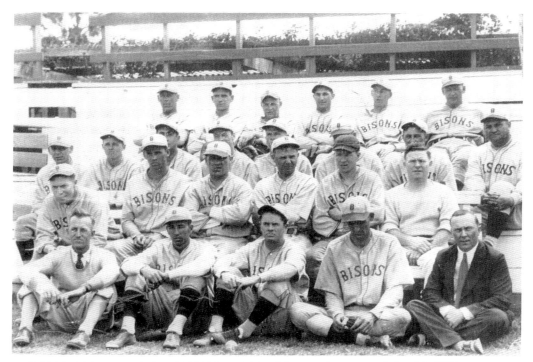

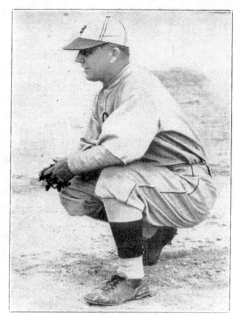

RAY SCHALK—1932 Bisons
Buffalo's Hustling Manager. With Milwaukee,
1911-12; with White Sox, 1912-28. 1929, with
Giants as coach; 1930-31, with Cubs, as coach.

Hope springs eternal. In this 1932 photograph from spring training, the Bisons pose on a wooden grandstand. This season would be a monumental one for Buffalo, as they had a new manager in Ray Schalk, who led the team to a 91-75 record, good for third place in the league. The Bisons were an offensive juggernaut that year, hitting 192 home runs, led by stalwart Ollie Carnegie in his first season as a Bison with 36 home runs and 140 RBIs. The team hit .299 for the season. (From the John Boutet Collection.)

This early baseball card/postcard giveaway shows manager Ray Schalk during the 1932 season. The Bisons had a fine year, with a record of 91-75, but finished in third place, 17 games behind the pennant-winning Newark Bears. (From the John Boutet Collection.)

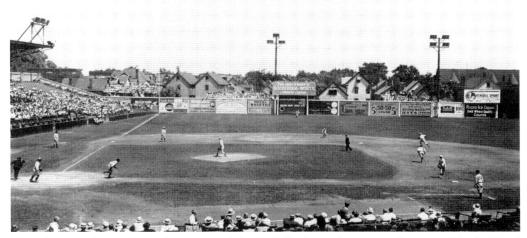

This photograph from Bison Stadium on July 14, 1932, shows the starting battery of Hank "Slim" Brewer pitching to Buck Crouse. Jess Hill of Newark hits into a double play, Billy Werber to Ottie Miller to Jim Poole. Brewer finished the season with a record of 17-12 and led the Bisons in the win column.

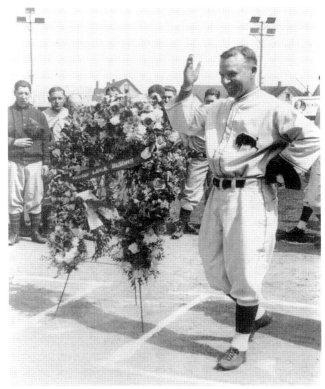

Bison manager Ray Schalk stands at home plate on opening day with the traditional wreath presented to the team as a symbol of good luck and well wishes for the upcoming season.

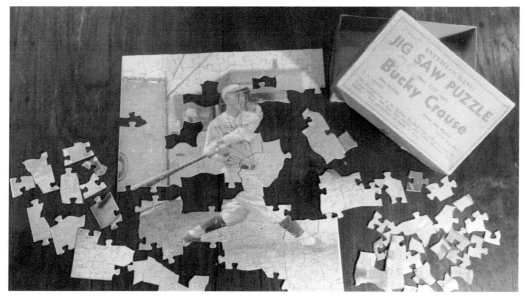

Bucky Crouse was one of the most popular Bisons of his day. He was catcher for two no-hitters, and during the 1935 season played in 32 straight games, including five doubleheaders in six days. He was honored with Bucky Crouse Night at Offermann Stadium in front of 13,000 fans. His best offensive season was in 1932, when he hit .270 in 121 games with 15 home runs. This was one of a series of more than 10 puzzles featuring players that were given away at Offermann Stadium during the 1930s. (From the John Boutet Collection.)

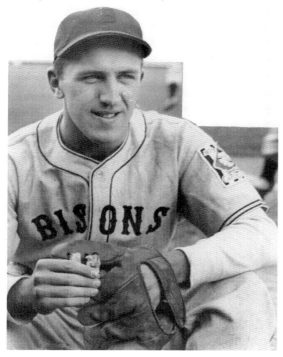

Cleveland Indians prospect Ray Mack, along with hall of famer Lou Boudreau, had an incredible season for Buffalo in 1939. The future double-play combo could both hit and field extremely well. Mack hit .293 with 15 home runs. The pair were involved in a contentious incident between the Bisons and their parent club the Indians when, despite the Bisons being in the running for the pennant and the Indians not in playoff contention, they were recalled to the big-league club. This doomed Buffalo's playoff hopes and ultimately ended the partnership between Cleveland and Buffalo, as the next season the Bisons entered into a new affiliation with the Detroit Tigers.

GATEWAY TO THE MAJORS

This Bisons jersey was worn during the 1940s. The team was the minor-league affiliate of the Detroit Tigers during this decade. (From the John Boutet Collection.)

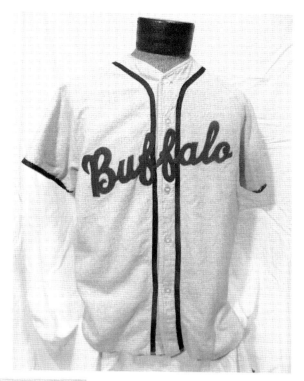

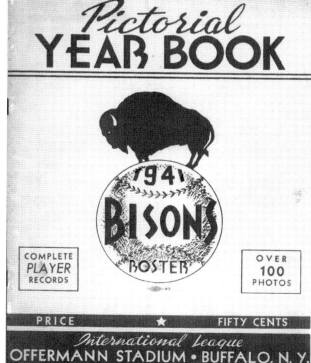

This yearbook is from the 1941 Buffalo Bisons season, which was marked by individual achievements. The team finished in third place with a record of 88-65, but lost to Montreal in the playoffs. (From the John Boutet Collection.)

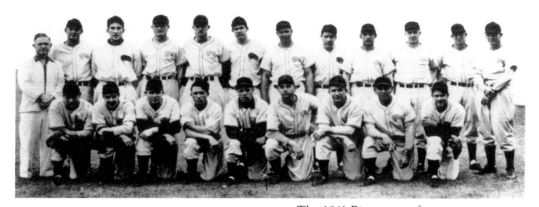

The 1941 Bisons pose for a team photograph. Fred Hutchinson led them that year with an incredible season. He went 26-7 with an ERA of 2.44. He struck out 171 batters against 47 walks and threw 31 complete games. Hutchinson went on to have an 11-year major-league career and managed for 10. Tragically, his managerial career and life were cut short in 1964 when he died at the age of 45 from lung cancer. The Hutch Award is given annually to a major league player "who best exemplifies the fighting spirit and competitive desire" of Fred Hutchinson by persevering through adversity. In 1972, the Fred Hutchinson Cancer Research Center was established in his name in Seattle, Washington.

In 1941, Virgil "Fire" Trucks pitched 33 games for the Bisons with a win-loss record of 12-12. The right-hander set a Bisons record with 204 strikeouts that year. Trucks had a major-league career record of 177-135 and 1,534 strikeouts. He won the World Series as a player in 1945 with the Detroit Tigers and in 1960 as a coach with the Pittsburgh Pirates. He also pitched two no-hitters during his career.

GATEWAY TO THE MAJORS

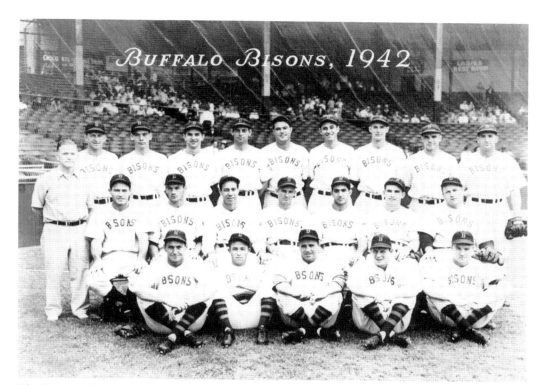

Buffalo Bisons, 1942

The Bisons released the iconic Ollie Carnegie on January, 22, 1942, and the team plummeted to seventh place in the league. The Bisons, pictured here in Offermann Stadium, were led statistically by several individuals. Replacing Carnegie in left field was Ed "Shovels" Kobesky, who hit 19 home runs and 75 RBIs. John Welaj accomplished an unusual baseball feat on July 3 that year when he singled and then proceeded to steal second, third, and home. Welaj finished the year batting .308 with 30 stolen bases.

Rufe Gentry pitched for the 1942 and 1943 International League Bisons. His best season was 1943. Appearing in 40 games, he posted a record of 20-16 with a 2.65 ERA. He led the league in innings pitched with 285 and had 184 strikeouts and 143 walks. Unfortunately, Gentry did not have a long major-league career. In 1946, when he was sent back to the minors, he had the misfortune to be cleaning a gun that went off, severely damaging the index finger on his pitching hand. He never won another game.

BASEBALL IN BUFFALO

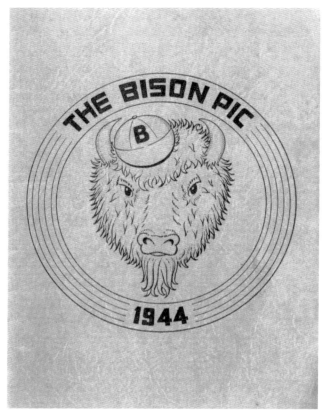

The Bison Pic souvenir book was given away during the 1944 season. It contained photographs and captions of the current Bisons. An interesting feature is its minimalist design due to the war effort. "This is not an elaborately planned and produced book," it explained. "Owing to present war-time restrictions, it was not intended to be a creation of art, but rather a simple and sincere effort, through photographs, to bring you in even closer contact with the players." The conservation effort during World War II even reached the baseball teams of America, while fans were reassured that the Bisons were still there for them on the home front.

Greetings

from the BUFFALO BISONS

The Buffalo International League Baseball Club presents the "Bison Pic of 1944" to you as a token of appreciation for your loyalty to the Buffalo Bisons. Its purpose is to make possible an even closer personal relationship between you, as a fan, and the players. We hope you will keep it as a friendly memento of the 1944 Bison team.

This is not an elaborately planned and produced book. Owing to present war-time restrictions, it was not intended to be a creation of art, but rather a simple and sincere effort, through photographs, to bring you in even closer contact with the players. We hope ownership of this book, "The Bison Pic", brings you as much pleasure as the creation of it has brought us.

THE BUFFALO BASEBALL CLUB.

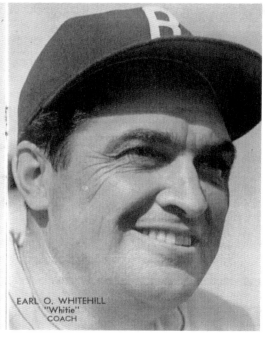

EARL O. WHITEHILL
"Whitie"
COACH

Victory Bound! In this 1945 program, the Bisons pay tribute to the war effort sweeping the nation. The program was printed in red, white, and blue. The wartime Bisons finished this season with a less-than-inspiring 64-89 record despite being managed by hall of famer Bucky Harris. (From the John Boutet Collection.)

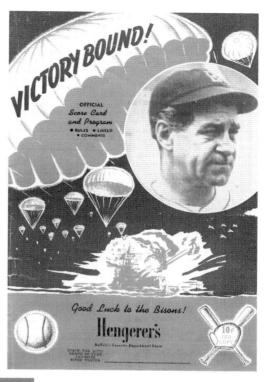

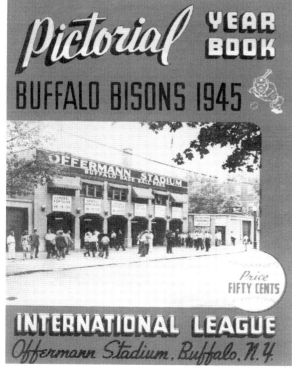

This 1945 yearbook treated fans to a wonderful view of Offermann Stadium from the Ferry Street entrance and the entrance to the bleachers. The ever-present homes that bordered the stadium are visible in the background. (From the John Boutet Collection.)

Paul "Rapier" Richards did it all in 1947, wearing the hats of player, manager, and general manager. Leading the Bisons to a record of 77-75, he also contributed at the plate with two home runs and 20 RBIs. He also specialized in getting ejected from games, amassing 14 ejections in one season alone, to earn the nickname of "Ol' Rant and Rave." In 1949, focusing on managing with only one at-bat, he led the Bisons to the pennant with a 90-64 record but lost in the playoffs to Montreal. (Courtesy of *Courier-Express* Baseball Series Images: Archives & Special Collections Department, E.H. Butler Library, SUNY Buffalo State.)

This image of Johnny Groth offers a good view of the hand-operated wooden scoreboard at Offermann Stadium. Groth only played in Buffalo for the 1948 season but registered an incredible stat line. He hit .340 and had 37 doubles, 16 triples, and 30 home runs. Groth was a center fielder with a strong arm, and a power hitter able to hit to all fields who went on to have a long major-league career, playing in 1,248 games with a career batting average of .279 in 15 seasons.

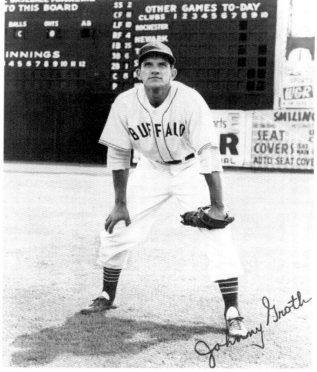

George "Specs" Toporcer managed the 1951 Bisons team until August 1. He was the first non-pitcher to wear glasses during his major-league career. Late in the season, he sent a runner home only to watch him be thrown out by 15 feet. His sight had gotten so bad that it forced him to resign as manager of the Bisons. He became an advocate for the visually impaired.

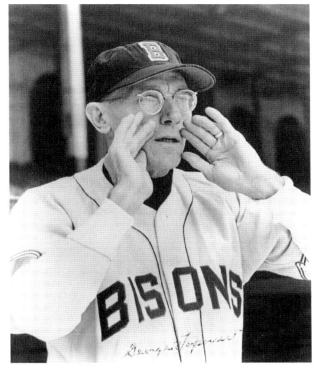

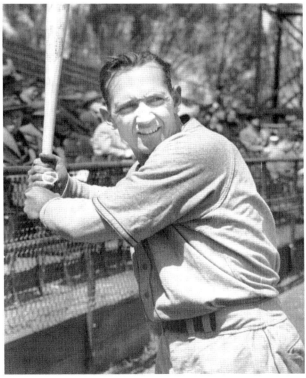

Coaker Triplett replaced George "Specs" Toporcer midway through the 1951 season. He guided the team the rest of the way to a fourth-place finish. Triplett had a stellar Bisons career, hitting over .300 in each of his six seasons in Buffalo, including leading the league with a .353 batting average in 1948. The next season, he knocked in 102 runs. He is a member of the Buffalo Bisons Hall of Fame.

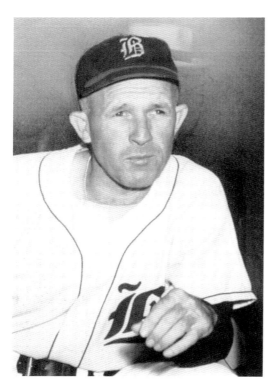

Jack Tighe learned the craft of managing in Western New York. In 1953, while guiding the team to an 86-65 record, he was subject to perhaps one of the first and only lie-detector tests in baseball. After being accused of spitting on an umpire and facing a one-year suspension, Tighe replied, "I didn't spit, I only spluttered." With his managerial career hanging in the balance, it was suggested that Tighe take the test. Tighe agreed, and after much fanfare, the results came back as "not guilty." The ban was lifted, but a $100 fine was imposed. (Courtesy of *Courier-Express* Baseball Series Images: Archives & Special Collections Department, E.H. Butler Library, SUNY Buffalo State.)

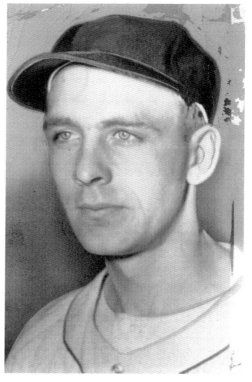

In 1952, Dick Marlowe accomplished one of the rarest feats in baseball, a perfect game with 27 outs and no base runners allowed. He accomplished this against the minor-league Baltimore Orioles on August 15. It was only the second perfect game in league history, and it would be 48 years until the next.

Frank Lary pitched two seasons of fine baseball for the Bisons. In 1953, he compiled a record of 17-11 in 223 innings with 117 strikeouts. The following season, he lowered his ERA from 4.00 to 3.39, tallying 15 wins against 11 losses and again proved be a workhorse with 207 innings pitched. He rang up 102 strikeouts on the season. (Courtesy of *Courier-Express* Baseball Series Images: Archives & Special Collections Department, E.H. Butler Library, SUNY Buffalo State.)

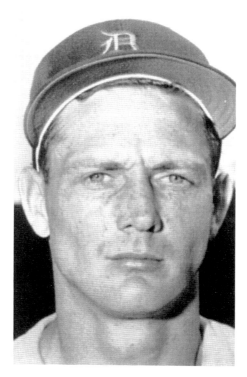

This jersey was worn by the Bisons during the 1950s, when the team was affiliated with the Detroit Tigers and Kansas City A's. (From the John Boutet Collection.)

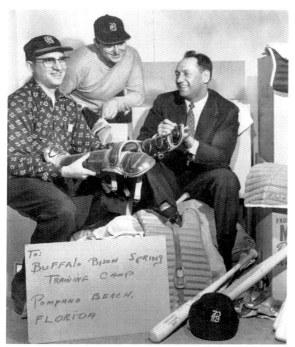

The Bisons prepare to depart for spring training in Pompano Beach, Florida, in 1955. The smiles would not last all season, as this was to become one of the worst Bisons teams in some time, with a record of 65-89. Managed by Buffalo native Dan Carnevale (right), the team was offensively challenged, with a team batting average of .249. The record was not the only bad news that year, as the Detroit Tigers pulled out of their agreement and intended to fold the franchise. This led to a bright note, as in 1956, the team became publicly owned through a stock ownership program.

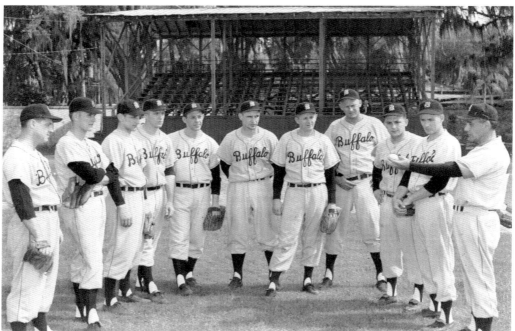

This is the Bisons spring training home in Florida at the start of the 1956 season, the first of three seasons for manager Phil Cavaretta (far right), who compiled a 221-236 record. From left to right are pitchers Ed March, Roger Bowman, Dan Lewandowski, Milt Jordan, John Weiss, Bob Schultz, Vic Stryska, Karl Drews, Mario Picone, and Harry Nicholas. (Courtesy of the Buffalo History Museum.)

During the 1950s, Buffalo, like most teams, enjoyed spring training in Florida. Their home for these months was in Pompano Beach. In the 1957 season, the Bisons finished 88-66 and won the pennant but lost the Little World Series to the Denver Bears, four games to one. (From the John Boutet Collection.)

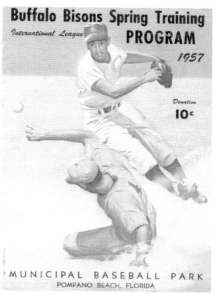

Buffalo Bisons Spring Training
International League **PROGRAM**
1957

Donation **10¢**

MUNICIPAL BASEBALL PARK
POMPANO BEACH, FLORIDA

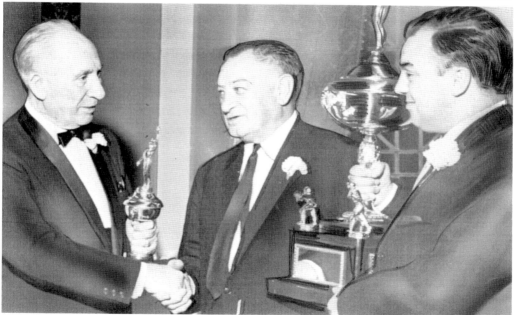

In 1955, the Detroit Tigers attempted to fold the Bisons franchise. This did not come to pass, thanks to the efforts of John Stiglmeir, among others, who came up with the idea to sell stock to the general public. The team became a community-owned franchise in 1956. Taken three years later, this photograph shows a complete reversal of fortunes for the Buffalo franchise. Stiglmeir (center) and general manager Don Labbruzzo (right) accept the Larry MacPhail trophy from the president of the National Association of Professional Baseball Leagues, George M. Trautman. This trophy is awarded to the minor-league franchise that does the best job of promotion. (Courtesy of the *Courier-Express* Baseball Series Images: Archives & Special Collections Department, E.H. Butler Library, SUNY Buffalo State.)

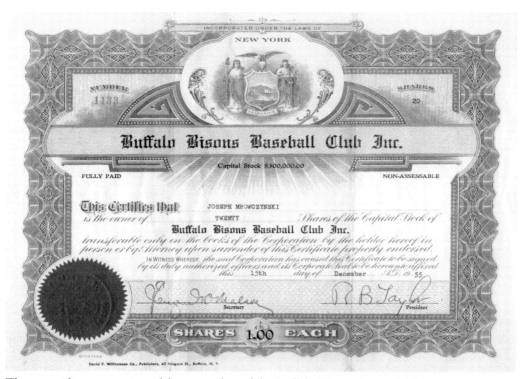

These certificates were issued for ownership of the Buffalo Bisons Baseball Club in 1956. Notice the signature of John Stiglmeir on the right. Stiglmeir spearheaded the effort for public ownership. The team would remain publicly owned until 1964. (From the John Boutet Collection.)

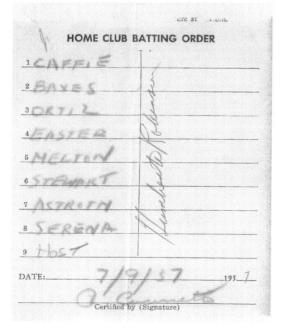

In this original 1957 lineup card, fan favorite and iconic Bison Luke Easter is batting in the clean-up spot. The card has been autographed by Humberto Robinson, who played the 1957 season with Toronto and had a stellar year. He would finish with an 18-7 record, 2.95 ERA, and 131 strikeouts. Not to be outdone by his pitching counterpart, Easter had a fine season of his own, hitting 40 home runs and finishing with a .279 average and 128 RBIs. (From the John Boutet Collection.)

GATEWAY TO THE MAJORS

In this action shot of Bison Mickey Harrington taken in the neighborhood ballpark Offermann Stadium on April 18, 1959, the tall outfielder rounds second base. This was the most productive of the three seasons Harrington spent with the Bisons, batting .301 with 43 runs scored. He would have a brief cup of coffee with the Philadelphia Phillies in 1963, appearing in one game as a pinch runner.

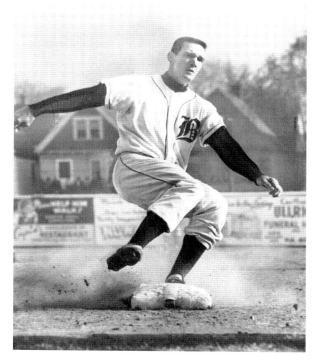

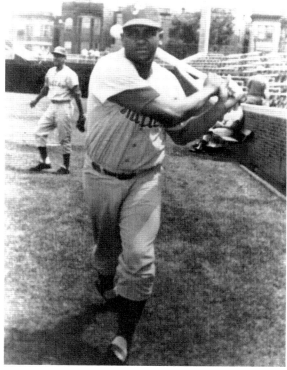

In 1959, the Bisons were the International League farm team for the Philadelphia Phillies. One of the Phillies' young prospects was Francisco "Pancho" Herrera. He helped lead the Bisons to a record of 89-64 that year while hitting for the International League triple crown (leading the league in average, home runs, and RBIs). Pancho hit .329 with 37 home runs and 128 RBIs. The Bisons won the pennant this season but lost in the playoffs to Richmond.

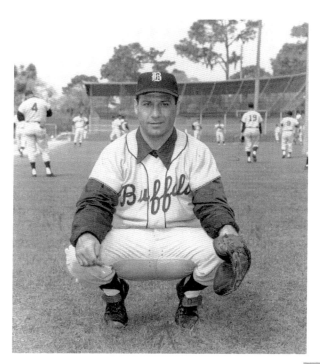

Joe Lonnett started his career with the Lockport Reds of the Pennsylvania–Ontario–New York (PONY) League. During his four-year tenure with the Bisons (1959–1962), this catcher would show more prowess with the glove. In 1960, he played in 75 games and had a fielding percentage of .981. He contributed 10 home runs that season as well. (Courtesy of *Courier-Express* Baseball Series Images: Archives & Special Collections Department, E.H. Butler Library, SUNY Buffalo State.)

This is an image from the beginning of the 1960 season of Bisons baseball. Each year, the team would be presented with a good luck wreath. This season, the receiving Bisons are Art Mahaffey (left) and Don Landrum. Landrum spent two seasons with the Bisons, his best being 1960. He boasted a .292 batting average with 18 home runs and 75 RBIs. His pitching counterpart Art Mahaffey also had a fine season in 1960. He posted a record of 11-9 with a 3.99 ERA and 136 strikeouts. The Buffalo team that year had an overall record of 78-75. (Courtesy of *Courier-Express* Baseball Series Images: Archives & Special Collections Department, E.H. Butler Library, SUNY Buffalo State.)

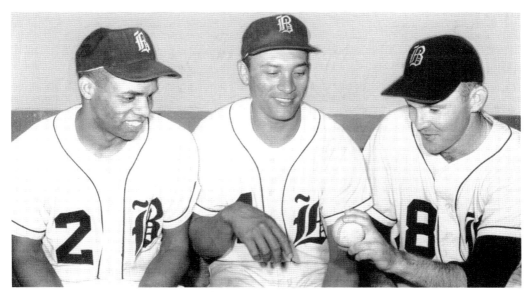

The Bisons in this August 13, 1961, photograph are, from left to right, Ted Savage, Felix Torres, and Wally Seward. Seward twirled a sparkling 2.55 ERA this season with 11 wins against only four losses. Torres hit for power and drove in 97 runs, while Ted Savage had a solid overall year with a .325 average, 24 home runs, and 65 RBIs. (Courtesy of *Courier-Express* Baseball Series Images: Archives & Special Collections Department, E.H. Butler Library, SUNY Buffalo State.)

In this June 29, 1961, photograph, from left to right, Bisons Dick Bunker, Wally Shannon, and Felix Torres discuss the finer points of baseball. Torres hit 24 home runs for the Bisons. "Lefty" Bunker only appeared in 12 games for the Bisons, sporting a record of 4-3 and an ERA of 3.86. Shannon's best season was the year after this one, when he posted a .294 batting average, 12 home runs, and 36 RBIs in 78 games played. (Courtesy of *Courier-Express* Baseball Series Images: Archives & Special Collections Department, E.H. Butler Library, SUNY Buffalo State.)

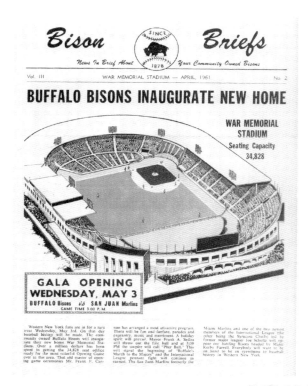

BUFFALO BISONS INAUGURATE NEW HOME

WAR MEMORIAL STADIUM

Seating Capacity
34,828

**GALA OPENING
WEDNESDAY, MAY 3**

BUFFALO Bisons *vs* SAN JUAN Marlins

GAME TIME 3:00 P.M.

This *Bison Briefs* mailer from April 1961 was sent to season ticket holders with details on that year's Buffalo Bison team. This edition commemorates the team moving to War Memorial Stadium. (From the John Boutet Collection.)

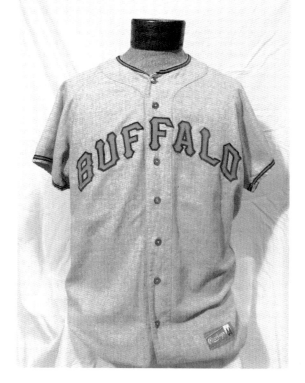

This jersey was worn by the team during the mid-1960s. The decade was one of flux for the Bisons, as they had four different parent organizations during that time: the Philadelphia Phillies, New York Mets, Cincinnati Reds, and Washington Senators. (From the John Boutet Collection.)

The 1965 season was not kind to the Bisons. In the first season under new ownership after the publicly owned shares were bought out, the team finished at 51-96. This program features one of the first appearances of the team's mascot, Buster Bison. Buster is still going strong rooting on the Bisons. (From the John Boutet Collection.)

Johnny Bench (fifth from right) was one of the only bright spots in 1967. With a record of 63-78 and a seventh-place finish, questions arose about the future of baseball in Buffalo. Due to a severe decline in attendance (one game counted only 117 fans), all home games were transferred to Hyde Park Stadium in Niagara Falls. Sunday home games remained at War Memorial Stadium, as they were played during the day. (Courtesy of *Courier-Express* Baseball Series Images: Archives & Special Collections Department, E.H. Butler Library, SUNY Buffalo State.)

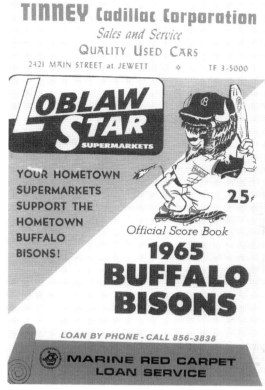

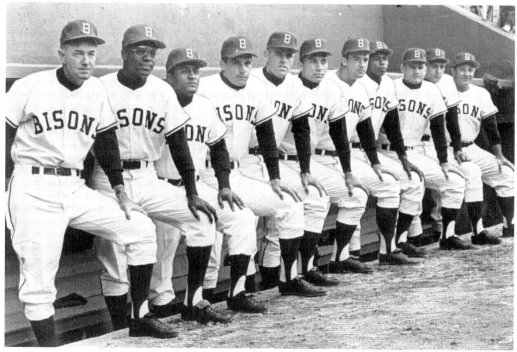

While only playing one season for the Bisons in 1967, Dick Stigman compiled a nice pitching line. In 21 games started and 132 innings pitched, he fanned 111 hitters. He pitched for seven years in the majors and had impressive strikeout totals. He whiffed 755 batters over his career, including 193 along with a 3.25 ERA in 1963. (Courtesy of *Courier-Express* Baseball Series Images: Archives & Special Collections Department, E.H. Butler Library, SUNY Buffalo State.)

One of the only highlights of the 1967 season may have been this team photograph giveaway. The Bisons finished in seventh place, despite hall of fame catcher Johnny Bench on the roster. Carling (O'Keefe) Brewery was founded in 1840 in London, Ontario. The company later merged with Molson and eventually became part of Molson-Coors Brewing Company. (From the John Boutet Collection.)

Courtesy of

CARLING BREWERY

1967 BUFFALO BISONS

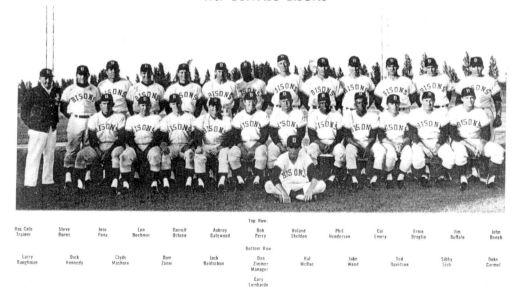

Top Row-

| Doc Cole Trainer | Steve Bares | Jose Pena | Len Boehmer | Darrell Osteen | Aubrey Gatewood | Bob Perry | Roland Sheldon | Phil Henderson | Cal Emery | Ernie Broglio | Jim Buffalo | John Bench |

Bottom Row

| Larry Baughman | Dick Kennedy | Clyde Mashore | Dom Zanni | Jack Baldschun | Don Zimmer Manager | Hal McRae | Jake Wood | Ted Davidson | Sibby Sisti | Duke Carmel |

Gary Lombardo

1970 BUFFALO BISONS
WAR MEMORIAL STADIUM
BUFFALO, NEW YORK

This 1970 score book is a unique item. It sports an advertisement for Genesee Beer, a favorite local beer brewed in Rochester since 1878. More importantly, this was the last season of baseball in Buffalo until 1979 due to low attendance, a lack of a working agreement with a major-league team, and no true home stadium. The Bisons had moved their home games to Hyde Park in Niagara Falls to try and drum up fan interest in the previous seasons, to no avail. The 1970 season saw the team back in War Memorial Stadium. After a dismal 9-29 start, the team only drew 9,204 fans over 13 home games. Something had to be done, and the team was relocated. This decision was reached on June 4, 1970, while the team was playing the Tidewater Tides. The team began the game as the Buffalo Bisons and ended as the Montreal Bisons, as the new parent club was the Montreal Expos. They subsequently moved to Winnipeg, Manitoba. (From the John Boutet Collection.)

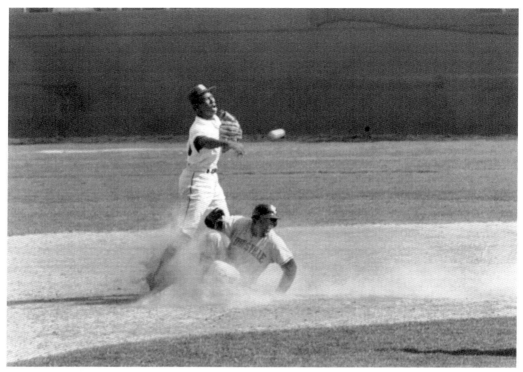

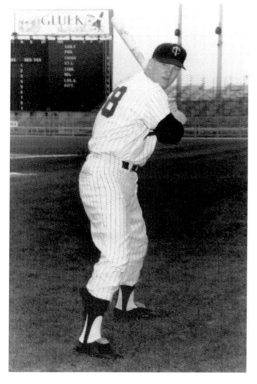

In this 1969 photograph, second baseman Tom Ragland of the Bisons attempts the double play against a hard slide from a Louisville player. Ragland played one season for Buffalo, hitting .252 in 135 games. Notice the characteristic high wall of War Memorial Stadium behind the players. (Courtesy of the Buffalo History Museum.)

Don Mincher played part of one season with the Bisons before his call-up to the majors. In 109 games, he hit 24 home runs and knocked in 66 runs. He was an all-star in 1967 and 1969. His all-star status in 1969 earned him a bit of interesting history. As the Seattle Pilots were only in existence for one season, he was one of only two Pilots to ever earn an all-star berth, along with Mike Hegan. He won the World Series in 1972 with the Oakland A's. (Courtesy of Courier-Express Baseball Series Images: Archives & Special Collections Department, E.H. Butler Library, SUNY Buffalo State.)

GATEWAY TO THE MAJORS

In the 1980s, the Bisons sported these jerseys to match their affiliate club, the Pittsburgh Pirates. (From the John Boutet Collection.)

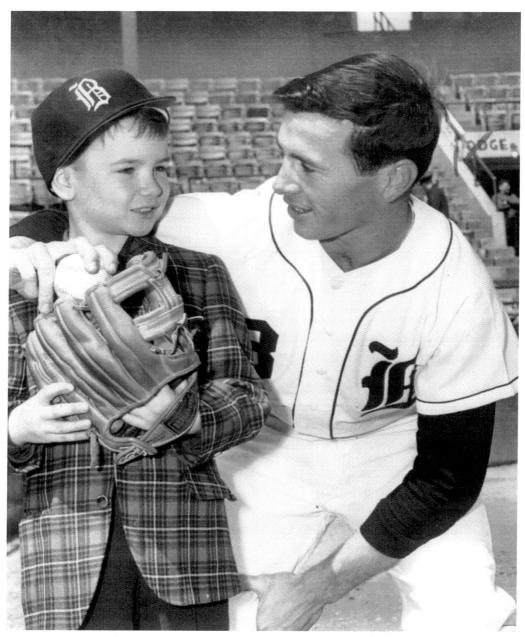

In this photograph from 1963, Bison Grimm Mason makes a new friend. Baseball will always be a timeless game. This young lad may have grown up to be anything in life, but will most likely always remember this experience. Grimm played one season for the Bisons and batted .250 as a third baseman and outfielder. (Courtesy of the *Buffalo News* Collection, the Buffalo History Museum.)

HALL OF FAMERS

The iconic Cincinnati Reds catcher Johnny Bench played two seasons for the Buffalo Bisons of the International League in 1966 and 1967. Though he only appeared in one game during 1966, he played 98 games for the Bisons the following year, hitting .259 and swatting 23 home runs while refining his catching ability. (From the John Boutet Collection.)

Johnny Bench, a catalyst of the Cincinnati Reds' "Big Red Machine," would have a hall of fame career. He won rookie of the year in 1968 and put up impressive numbers over a 16-year career. He was a 14-time all-star, World Series champion in 1975 and 1976, and added World Series MVP to his résumé in 1976. A standout catcher, he earned 10 Gold Gloves. Finishing with career totals of a .267 batting average, 2,048 hits, 389 home runs, and 1,378 RBIs, he was elected to Cooperstown in 1989 on his first ballot.

Here a young Johnny Bench listens with rapt attention as a fellow Bison coach or player explains what it takes to be a hall of famer. (From the John Boutet Collection.)

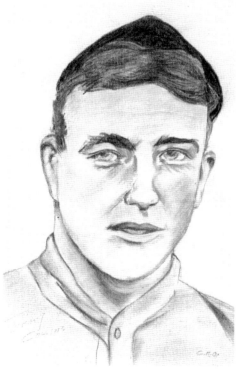

This wonderful sketch of Jimmy Collins by Clara Overfield honors a Buffalonian and hall of famer. Jimmy Collins was born in Buffalo on January 16, 1870, died in Buffalo on March 6, 1943, and is buried in Buffalo. In between, he had a sensational career as a major-leaguer. He played for Buffalo's Eastern League entry in 1893 and 1894. His best season for these Bisons was in 1894. Jimmy bat .352 with 52 doubles and 126 runs scored. He started his major-league career the next season with the Boston Beaneaters and played in the majors until 1908, accumulating a career batting average of .294 with 65 home runs and 983 RBIs. He was a player manager from 1901 to 1906 with the Boston Americans (Red Sox) and compiled a record of 455-376 along with winning the first ever World Series in 1903. At the height of the dead-ball era, he led the National League in home runs in 1898 with 15. He was inducted posthumously into Cooperstown in 1945. (Courtesy of the Joe Overfield Collection, the Buffalo History Museum..)

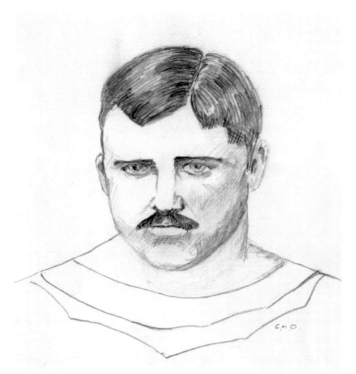

Jim "Pud" Galvin was one of the most storied players to play for the franchise. His statistics read like fictitious numbers, with 705 games pitched, a record of 365-310, a career ERA of 2.85, and a staggering 6,003.1 innings hurled. His best season was probably in 1884 for Buffalo of the National League, where he posted a sparkling 1.99 ERA and a record of 46-22 while pitching in 72 games (71 of them complete) and 636.1 innings. He was elected to Cooperstown in 1965. (Courtesy of the Joe Overfield Collection, the Buffalo History Museum.)

Charles "Old Hoss" Radbourn only appeared in six games and hit a paltry .143 for the Bisons; he was given his release in June 1880. Landing the next season with Providence, he went on to have a lifetime record of 309-194 with a 2.68 ERA. His greatest season was in 1884 with the Providence Greys, where he won a major-league-record 59 games and had a sterling 1.38 ERA. He pitched a no-hitter on July 25, 1883. He was inducted into Cooperstown in 1939. (Courtesy of the Joe Overfield Collection, the Buffalo History Museum.)

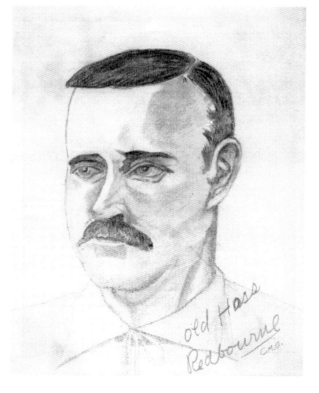

An amazing talent, Dan Brouthers was part of the Buffalo Bisons' "Big Four." His career spanned from 1879 to 1896, with a return in 1904 to the New York Giants. With a career .343 batting average, 2,296 hits, and 1,296 RBIs, his hitting résumé was long and storied. He won the National League batting crown in 1882, 1883, 1889, and 1892; the 1882 and 1883 seasons were spent with the Buffalo Bisons. He was inducted into Cooperstown in 1945. (Courtesy of the Joe Overfield Collection, the Buffalo History Museum.)

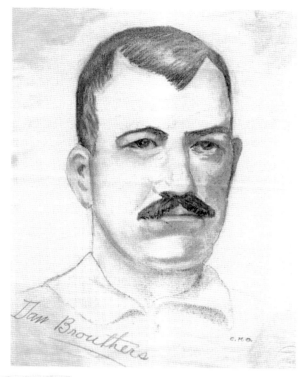

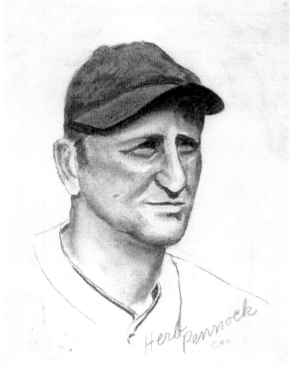

Herb Pennock spent one season as a hurler for the Bisons in 1916. With a record of 7-6 but a sparkling ERA of 1.67, he helped lead the team to the pennant. He went on to have a hall of fame career, earning four World Series honors with the New York Yankees in 1923, 1927, 1928, and 1932. Pitching for the famed 1927 "Murderers Row" Yankees, he posted a record of 19-8 with a 3.00 ERA and won game three of the World Series versus Pittsburgh by a score of 8-1, holding the Pirates hitless for more than seven innings. (Courtesy of the Joe Overfield Collection, the Buffalo History Museum.)

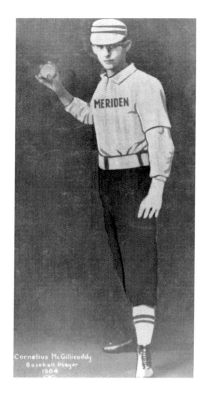

Cornelius "Connie Mack" McGillicuddy—no name may be more synonymous with baseball managers. Known for his trademark suit in the dugout, he managed an incredible 7,679 games with a record of 3,731-3,948. He is most famous for being manager of the Philadelphia Athletics, who he guided to five World Series wins. His induction into Cooperstown came in 1937. He spent the 1890 season with the Buffalo Bisons of the Players League, where in 123 games he batted .266 with 134 hits and 53 RBIs.

John Montgomery Ward was one of the original Bisons when the team played its first season in 1877 as an independent team. He appeared as a 17-year-old infielder and pitcher. One of the pioneers of the game, he had a 17-year career in the major leagues. He had impressive statistics both batting and pitching. With a career .275 average, 2,104 hits, 867 RBIs, and 540 stolen bases, he also compiled a record as a pitcher of 164-103 with an ERA of 2.10 and 920 strikeouts. He also hurled a perfect game on June 17, 1880. John. M. Ward was inducted into the hall of fame in 1964.

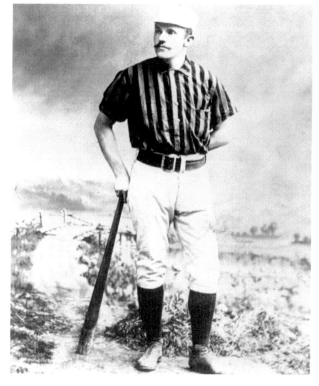

HALL OF FAMERS

"Tinker to Evers to Chance, / Trio of bear cubs and fleeter than birds." There is perhaps no greater triumvirate of players in baseball lore than the double-play combination of the Chicago Cubs from 1906 to 1910. The shortstop of this combination was Joe Tinker (pictured). He spent part of the 1930 season with the Buffalo Bisons as a coach. Fleet of foot, he stole 336 bases in his career. During his time in the majors, he won two World Series with the Cubs in 1907 and 1908. Tinker was elected to Cooperstown in 1946.

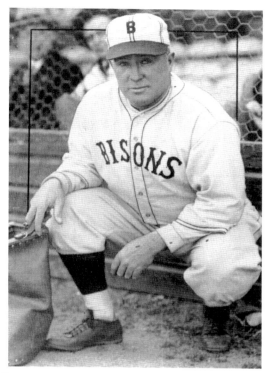

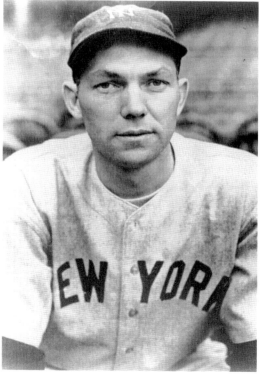

Hall of famer Bill Dickey only played a few games for Buffalo in 1928 before being called up to the majors by the New York Yankees. With the Yankees, he won an unprecedented 14 World Series titles as a player and a coach and become an 11-time all-star. He owned a career .313 batting average, with 202 home runs and 1,209 RBIs. He was also player-manager of the Bronx Bombers for part of the 1946 season, with a record of 57-48. In 1949, Dickey returned to the Yankees as a coach and catching instructor.

While playing for Buffalo in 1919, Bucky Harris collected a .282 batting average combined with 126 hits. He was elected to the hall of fame in 1975 based on his managerial prowess. Compiling a record of 2,158-2,219, he managed five teams and guided Washington to three World Series appearances, including a victory in 1924 over John McGraw's New York Giants. He also led the New York Yankees to the 1947 title. He managed the Bisons to a record of 142-165 in 1944 and 1945.

Gabby Hartnett managed the Bisons to a 78-75 record in 1946, taking over for Bucky Harris, who had become the general manager. Catching for the Chicago Cubs from 1922 to 1940 as well as player-managing from 1938 to 1940, he compiled all-star numbers, posting a career average of .297 with 236 home runs and 1,179 RBIs. He was a six-time all-star, and was National League MVP in 1935 with a .344 batting average, 13 home runs, and 91 RBIs. He garnered his hall of fame accolades on his 11th ballot in 1955.

Lou Boudreau was a hall of fame shortstop who played for the Bisons in 1939. Hitting .331 with 17 home runs, he showed what would make him an eight-time all-star, American League MVP, and World Series winner in 1948 with the Cleveland Indians. He was a player-manager with the Indians as well and finished with a career managerial record of 1,162-1,224. He was enshrined in Cooperstown in 1970. In a 15-season career, he finished with a batting average of .295, with 68 home runs and 789 RBIs to go along with 1,779 hits.

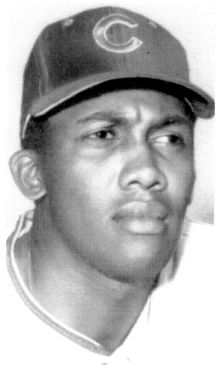

Ferguson "Fergie" Jenkins pitched three games for the Bisons in 1962 with a record of 1-1, a 6.23 ERA, and six strikeouts. His career spanned from 1965 to 1983. He was a three-time all-star and posted a career record of 284-226 with a 3.34 ERA and 3,192 strikeouts. He was the National League Cy Young Award winner in 1971 and was inducted into the hall of fame in 1991. (Courtesy of *Courier-Express* Baseball Series Images: Archives & Special Collections Department, E.H. Butler Library, SUNY Buffalo State.)

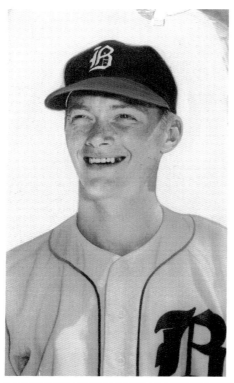

Jim Bunning played for Buffalo in 1955. He compiled an 8-5 record with a 3.77 ERA and 105 strikeouts over 129 innings pitched. Over a career spanning from 1955 to 1971, he was a nine-time all-star, pitching both a perfect game and a no-hitter. He finished with 2,855 career strikeouts and was elected to Cooperstown in 1996. After his baseball career, Bunning went on to be elected to the House of Representatives and later served two terms as a US senator from his native Kentucky.

As a part of the Old Timer's Day game called Buffalo's Grand Old Game, Willie Mays works out in the batting cage. Mays, considered by many to be one of the best center fielders of his generation, was inducted into the hall of fame in 1979. His career résumé is legendary, with a lifetime .302 batting average, 3,283 hits, 660 home runs, 1,903 RBIs, and 338 stolen bases. A 24-time all-star, he may best be remembered for "The Catch," an over-the-shoulder grab in deep center field during the 1954 World Series.

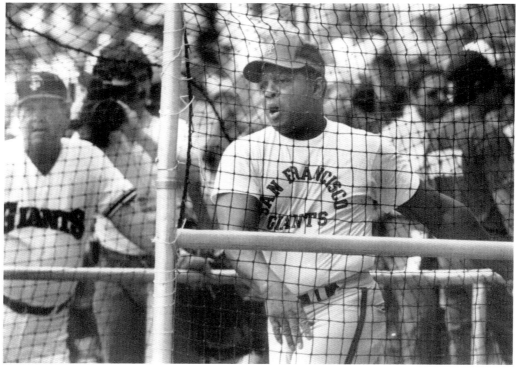

HALL OF FAMERS

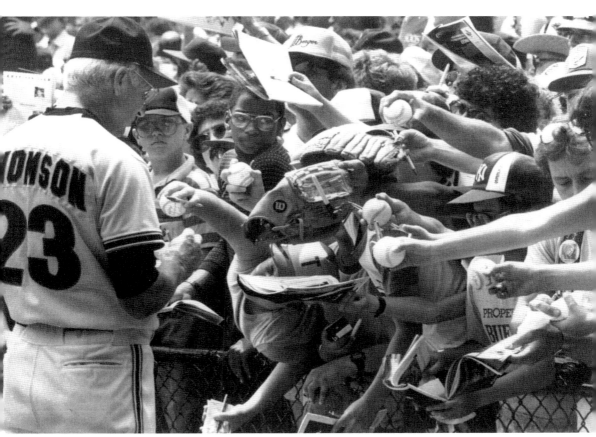

In June 1984, War Memorial Stadium hosted Buffalo's Grand Old Game, a touring baseball game of 12 hall of famers and many other famous players from baseball lore. Here Bobby Thomson signs autographs. Thomson is best remembered for his iconic home run, called "The Shot Heard 'Round the World," which was hit off of Brooklyn Dodgers pitcher Ralph Branca and propelled the New York Giants to the pennant and the World Series in 1951 after a three-game playoff to decide the winner of the National League. (Courtesy of the *Buffalo News* Collection, the Buffalo History Museum.)

OLDTIMERS GAME '85

A Buffalo Baseball Centennial Celebration

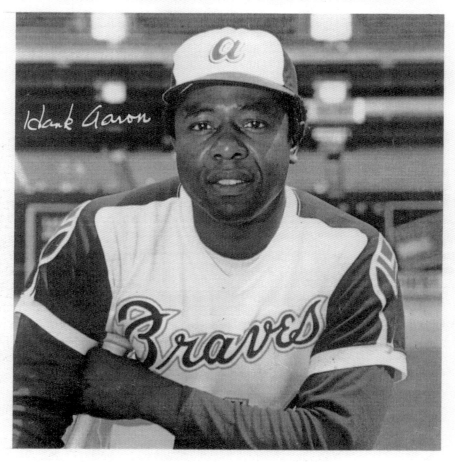

July 26, 1985
WAR MEMORIAL STADIUM
Buffalo, N.Y.

This program is from the 1985 Oldtimers Game held at War Memorial Stadium. This year featured home run king Hank Aaron. Aaron hit 755 home runs in 21 seasons, which was good for first place all-time until the record was broken by Barry Bonds in 2007. (From the John Boutet Collection.)

LOCAL HEROES

There may be no greater Buffalo Bison than Ollie Carnegie. Playing for the Bisons from 1931 to 1941 and again in 1945, he was an incredible talent with the bat. He hit 258 career home runs for the Bisons, swatted 249 doubles, had a career batting average with the team of .308, and recorded 1,362 hits. In 12 seasons, he posted a batting average over .300 seven times. He was a stalwart of longevity, posting an amazing 4,445 games played. What may be even more incredible is the fact that his first season with the Bisons was at the age of 32. (From the John Boutet Collection.)

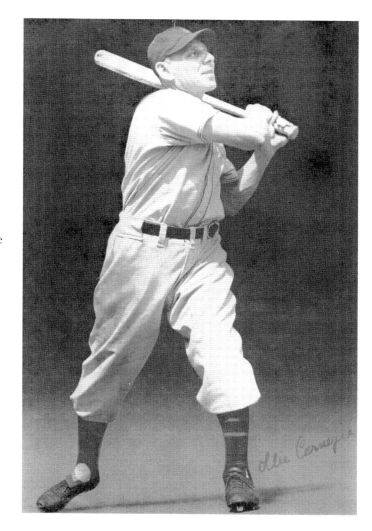

Ollie Carnegie's list of accolades is impressive indeed. In 1938 and 1939, he led the International League in home runs. He also won MVP of the International League in 1938. In 1947, he was inducted into the International League Baseball Hall of Fame. He is still the International League's all-time RBI leader. He is only one of three Buffalo Bisons to have their number retired (No. 6). In 1985, he was inducted into the Buffalo Baseball Hall of Fame, and in 1992, he was inducted into the Greater Buffalo Sports Hall of Fame.

While known as an outstanding hitter, Carnegie was no slouch with the glove by any means. In 133 games in 1932, he had a fielding percentage of .985.

LOCAL HEROES

In this undated photograph, Ollie Carnegie (left) poses with an unidentified Bison player. After 12 seasons with the minors, Carnegie managed the Jamestown PONY League team for one season in 1945. (From the John Boutet Collection.)

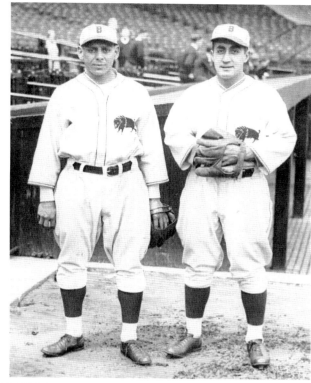

Which one is the icon? In this undated photograph, Carnegie (left) poses with the "Sultan of Swat." It may not generally be known that Babe Ruth was a coach for the Brooklyn Dodgers at the end of his career, which is why he is not in his familiar pinstripes.

What to do when an icon becomes a scout? Give him his own custom car, of course. Here Carnegie the Bison scout chats with a passerby, perhaps for hitting tips, perhaps for directions. (From the John Boutet Collection.)

LOCAL HEROES

Like an artist with his paintbrush, Luke Easter displays the tools of his craft. The perfect balance of power and average, Luke could do seemingly anything with his bat. He totaled RBI numbers of 106, 128, and 109 in his three full seasons with the Bisons from 1956 to 1958 (1959 was split between Buffalo and Rochester with 76 RBIs). Tragically, Easter was murdered by armed robbers in Euclid, Ohio, while transporting $35,000 in payroll checks on March 29, 1979. (Courtesy of *Courier-Express* Baseball Series Images: Archives & Special Collections Department, E.H. Butler Library, SUNY Buffalo State.)

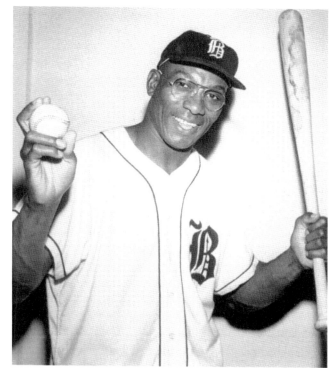

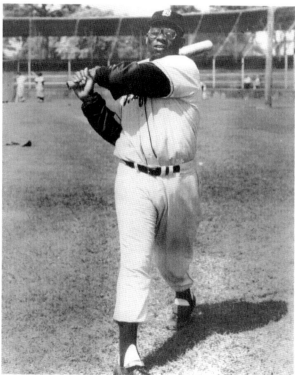

"Luuuuuuke" rang through the ballpark when this 6 foot, 4 inch, 230-pound gentle giant stepped to the plate. Luke Easter accomplished the impossible on June 14, 1957, when he hit a ball where no one had before. The home run off Columbus pitcher Bob Kuzava traveled over the 40-foot scoreboard in right center field and landed on the roof of a house on Woodlawn Avenue. The drive was estimated at 506 feet. One month later, on August 15, he did the unthinkable and cleared the scoreboard yet again. Easter's number was retired by the Bisons, he was a charter member of the Buffalo Baseball Hall of Fame in 1985, and he was inducted into the Greater Buffalo Sports Hall of Fame in 1989.

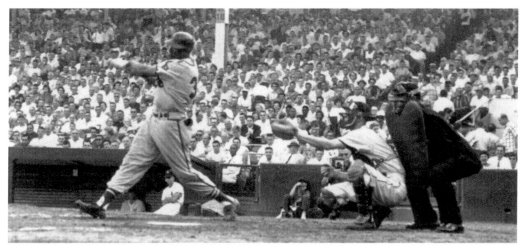

While Easter is wearing the wrong uniform for the locals to adore him in, he still shows off his sweet left-handed power stroke. In 13 minor-league seasons, he hit 269 home runs, and 93 in six major-league seasons. He stroked 113 of those home runs in a Bison uniform for three full years while hitting 22 home runs in 1959 as a member of the Bisons and the Rochester franchise.

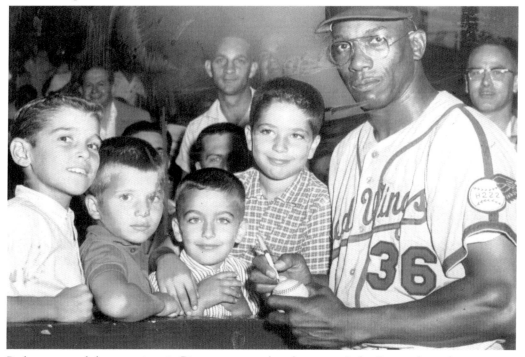

Perhaps one of the most iconic Bisons ever to play the game, Luke Easter shows his generous nature in signing autographs for fans. He is shown in a Rochester Red Wings uniform. The Bisons gave him his release on May 14, 1959, and in only a few short days, he signed with Rochester. (Courtesy of *Courier-Express* Baseball Series Images: Archives & Special Collections Department, E.H. Butler Library, SUNY Buffalo State.)

In 1958, children would most likely beg their parents to buy a copy of the *Courier-Express* to collect all their favorite Bison players. Here Luke Easter sports the classic 1950s Bisons uniform from this set. (From the John Boutet Collection.)

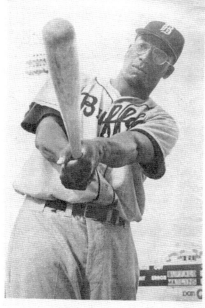

Your BUFFALO BISONS

No. 4. LUKE EASTER. First Baseman

Luke Easter, always loved by the people of Buffalo, strikes his classic left-handed batting stance in front of some fans. The photograph was taken on the field at Offermann Stadium during a kids' day promotion. (From the John Boutet Collection.)

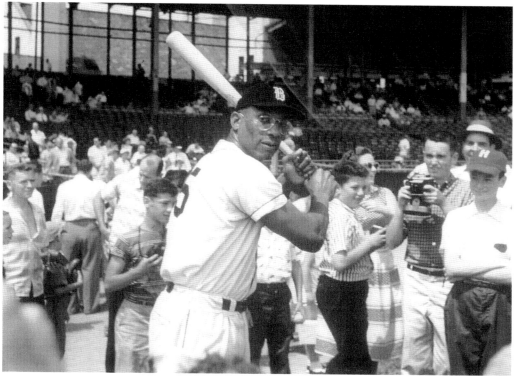

The visionary Frank J. Offermann was the owner of the Buffalo Bisons from 1928 to 1935. In 1930, he became one of the first team owners to introduce night baseball to Western New York. Another innovation of his was to broadcast his team's games on the radio, again one of the first teams to do so. Offermann was a promoter extraordinaire, offering Ladies Night and drawings for an automobile that offered increased odds based on the number of games attended. Upon his death in 1935, the club's board of directors voted to rename Bison Stadium as Offermann Stadium. Frank Offermann was inducted into the Bisons Hall of Fame in 1985 and the Greater Buffalo Sports Hall of Fame in 2016.

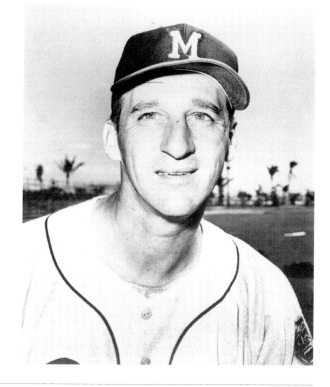

"Spahn and Sain and pray for rain" was the rallying cry for the 1948 Boston Braves. Inspired by a poem by *Boston Post* sports editor Gerald V. Hern, the theory in the pennant run was that the Braves would pitch first Warren Spahn (pictured), then Johnny Sain, then an off day, followed by a rain day to repeat the process. While Spahn never pitched for Buffalo, he grew up in the city, attending South Park High School on Southside Parkway in South Buffalo.

Local boy Warren Spahn doffs his cap to the faithful at War Memorial Stadium during Buffalo's Grand Old Game in 1984. Spahn had a truly fantastic hall of fame career pitching for the Boston/Milwaukee Braves, New York Mets, and San Francisco Giants. A 17-time all-star and a World Series winner in 1957 who threw two no-hitters, he was elected to Cooperstown in 1973. His statistics speak for themselves, including 363 wins, 2,583 strikeouts, and a Cy Young Award in 1957. He may have been the best athlete to ever come from South Buffalo.

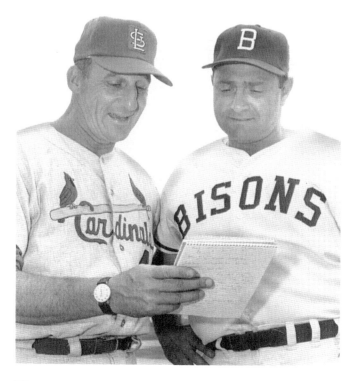

Warren Spahn (left) confers with Bison coach Sibby Sisti from Buffalo and a Canisius High School alumnus. Spahn had a hall of fame career as a pitcher, and Sisti was the ultimate utility player, playing every position except pitcher and catcher over a 13-year career encompassing 1,016 games. Sisti also played a role as both an advisor and an actor in *The Natural*, filmed in Buffalo's War Memorial Stadium. (Courtesy of *Courier-Express* Baseball Series Images: Archives & Special Collections Department, E.H. Butler Library, SUNY Buffalo State.)

Joe McCarthy, the iconic manager of the New York Yankees, also played for the Bisons. "Marse Joe's" Buffalo connections run deep. Graduating from Niagara University, he played two seasons for the Buffalo Bisons. His best season was in 1915, when he batted .266 with 24 doubles and 17 stolen bases. He is most famously known as a manager in the big leagues for 24 years, most successfully with the New York Yankees, leading them to eight pennants and seven World Series titles. His record as a manager was an astounding 2,125-1,333. He was elected to the National Baseball Hall of Fame in 1957 as a manager. He died in Buffalo in 1978 and is buried in Mount Olivet Cemetery.

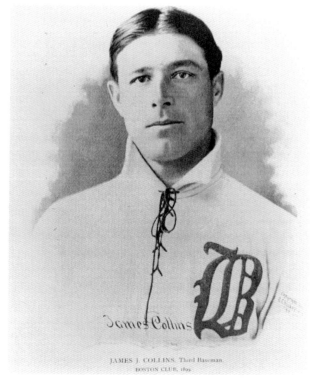

JAMES J. COLLINS, Third Baseman.
BOSTON CLUB, 1899

Buffalonian Jimmy Collins had a unique honor bestowed upon his name. Upon his election to Cooperstown, he was the first player inducted as primarily a third baseman. A wizard at the "hot corner," he also was one of the first ever third basemen to regularly field bunt attempts. Before Collins, only the shortstop would field this play. Collins's Irish wake in Buffalo has been immortalized in the song "Jimmy Collins' Wake" by the Dropkick Murphys.

LOCAL HEROES

In 1956, these two Brooklyn Dodgers combined for one of the rarest feats in baseball, a no-hitter. On September 25, 1956, Niagara Falls native Sal "The Barber" Maglie (right) and Roy Campanella threw one against the Philadelphia Phillies. Maglie compiled a stellar 2.87 ERA and 108 strikeouts for the Brooklyn team. (Courtesy of *Courier-Express* Baseball Series Images: Archives & Special Collections Department, E.H. Butler Library, SUNY Buffalo State.)

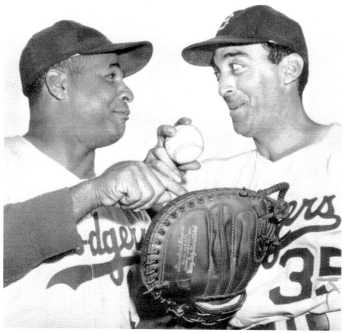

In 1956, Sal Maglie enjoys a laugh with two Brooklyn teammates, Jackie Robinson (left) and Gil Hodges. Born in Niagara Falls, Maglie played for the Niagara Purple Eagles, the Niagara Falls/Jamestown franchise in the PONY League, Elmira of the Eastern League, and the Buffalo Bisons before going on to a 10-year major-league career. Maglie played three seasons for the AA Bisons. In the majors, he played for five teams, including all three New York teams (Giants, Dodgers, and Yankees), was a two-time all-star, and won a World Series. (Courtesy of *Courier-Express* Baseball Series Images: Archives & Special Collections Department, E.H. Butler Library, SUNY Buffalo State.)

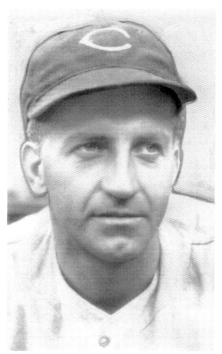

Native Buffalonian Frank Pytlak had a long and impressive career. He cited his most impressive moment in his career as "throwing out Ty Cobb on a steal attempt," but he had many others as well. He was the catcher for Cleveland ace Bob Feller's 18 strikeouts in a single game in 1938. The same year, he caught a baseball dropped from the top of the Cleveland Tower, a height of 708 feet. A graduate of Buffalo's Masten Park High School, he played three seasons for the Bisons. His most impressive offensive season was 1931, when he batted .306 in 73 games. He was inducted into the Greater Buffalo Sports Hall of Fame (Courtesy of *Courier-Express* Baseball Series Images: Archives & Special Collections Department, E.H. Butler Library, SUNY Buffalo State.)

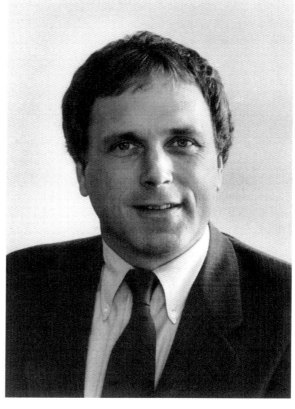

Robert Rich Jr. is the current owner of the Buffalo Bisons of the International League. Rich purchased the team in 1983 and was an instrumental player in the attempt to lure major-league baseball back to Buffalo in the early 1990s. He is the chairman of Rich Products, a Buffalo-based dairy product company founded in 1945.

LOCAL HEROES

Many Buffalo public school children will remember Buffalo native Babe Birrer as their gym teacher, this author included. But before that, Birrer was a longtime Bisons player, pitching for them for nine seasons and going on to the majors for three. Statistically, his best season for Buffalo was in 1964, when he compiled a record of 7-4, an ERA of 3.02, and 84 strikeouts. Babe Birrer is saddled with a rather ignominious piece of Buffalo baseball history, as he took the final loss in Offermann Stadium.

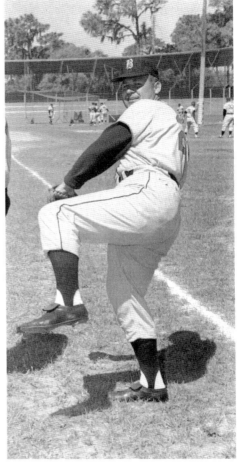

Local boy Kevin Koebel is from the small town of Colden, about 20 minutes outside of Buffalo in the Boston Hills. He attended St. Francis High School and had a six-year big-league career. While playing for some unspectacular teams, he put together some decent stats. In 1978, he had a record of 5-6 but a nice 2.91 ERA. The next season, he pitched 161.2 innings and compiled a 3.51 ERA. (Courtesy of *Courier-Express* Baseball Series Images: Archives & Special Collections Department, E.H. Butler Library, SUNY Buffalo State.)

Two iconic non-players represent baseball in Buffalo. Mascot Buster Bison has been a staple of the team ever since his first appearances in 1965. To the left is Earl P. Howze Jr., known as "The Earl of Bud." This beer vendor brought the crowd to its feet as he performed the "Pee-Wee Herman Big Shoe Dance" to the song "Tequila" by Chuck Rio. His dance across the dugout roof in his trademark tuxedo and red shoes was an event not to be missed at each Bisons game. He would also dance at Memorial Auditorium for the Buffalo Sabres crowd to the same song, only on a concrete railing about six inches wide. (From the John Boutet Collection.)

LOCAL HEROES

6

FOR THE LOVE
OF THE GAME

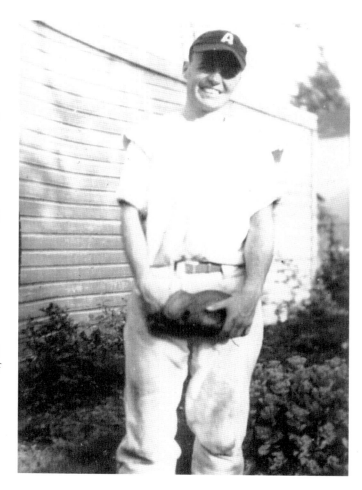

This smiling gentleman is John Boutet's father, Paul. The knowing grin on his face lights up the world because to Paul Boutet, there was nothing more perfect than the game of baseball. The weathered glove on his hand was his prized possession, and he was always up for a game of toss. Like every father, he awaited that moment when his son would walk in and ask the age-old-question, "How 'bout a game of catch?" Fathers like Paul are reminders that often, baseball is simply played for the love of the game. Thanks to parents, this love of baseball and passion for the national game has been instilled in people around the country. (From the John Boutet Collection.)

PLAY BALL!

Toronto vs. Buffalo

SUNDAY, JUNE 7th

at the **BISON STADIUM**

A Gala Day for the Kids!

Absolutely FREE to every boy or girl up
to 17 years of age a

**Baseball Bat, Player's Glove and
Genuine Horsehide Covered Ball.**

A paid grandstand seat will entitle you
to the above. Remember the date

SUNDAY, JUNE 7th

What child would not want to attend this? Unlike the promotions of today, where everything is limited to the first 18,000 fans, these children would get a bat, a glove, and a ball. Promotions like this were intended to get the youth of Buffalo playing ball and becoming greater fans of the Bisons. This promotion would have been sometime between 1924 and 1935, as Bison Stadium was renamed Offermann Stadium in 1935. (From the John Boutet Collection.)

Perhaps no other game has filled imaginations with as many dreams of being a hero. Every boy who steps to the plate with a stick in hand and a ball coming toward him is in a faraway stadium in his mind's eye. It is always game seven of the World Series and the pitcher has just hung a curve ball. His eyes grow wide as the pitch comes in flat, level, and perfect, and he sets his stance, cocks the bat, exhales, and swings with all his might, knowing the ball will sail out of the stadium into the great beyond. This streetball game is from Buffalo's West Side in the 1970s. (Courtesy of the Buffalo History Museum.)

FOR THE LOVE OF THE GAME

In the undated photograph at left, a member of a Kenmore women's team blows a giant bubble while waiting to hit the ball. Women have played an integral role in every era of baseball and softball. What does a player do when bored with game action and tired of sitting on a crate of balls? He sees how far he can stretch his gum. In the photograph at right, from 1968, B.J. Pfluger is all about the wad of chewing gum. (Both, courtesy of the Buffalo History Museum.)

In this 1960s photograph, onlookers watch local amateur action at a Buffalo park. Many youth and minor leagues have been prevalent across the city from this time to the present day. (Courtesy of the Buffalo History Museum.)

This is a 19th-century baseball team from Buffalo. It is unclear if this was a league team or an all-star team. During this era, uniforms would be created to commemorate an occasion (the 1906 New York Giants wore uniforms with "World Champions" emblazoned on the front). From left to right are (first row) Al C. Bidwell, Patrick Roache, William Adler, Frank Baritot, and Arthur Chamberlain; (second row) John McHugh, John Bosse, Charles Klotz, and Arthur Esspord. (Courtesy of the Buffalo History Museum.)

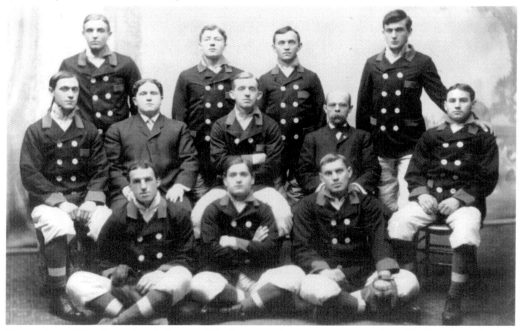

This is the 1905 Pullman baseball team. The Pullman Company was located at 1770 Broadway Avenue and made railroad cars. (Courtesy of the Roy Nagel Collection, the Buffalo History Museum.)

FOR THE LOVE OF THE GAME

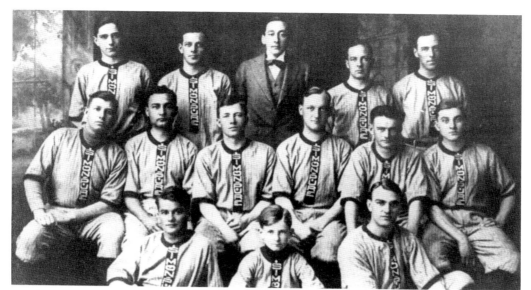

Baseball and beer have always gone hand-in-hand. Many local breweries surrounded Offermann Stadium, including Simon Pure, represented by the team in this photograph. Simon Pure was an employer of many local Buffalonians who worked through the local brewers' union based on which brewery needed their services at that time. Early attendees to Bisons games used the Simon Pure parking lot for free parking. This photograph is from the years 1911–1913, when Simon Pure won the Buffalo city championship. (Courtesy of the Buffalo History Museum.)

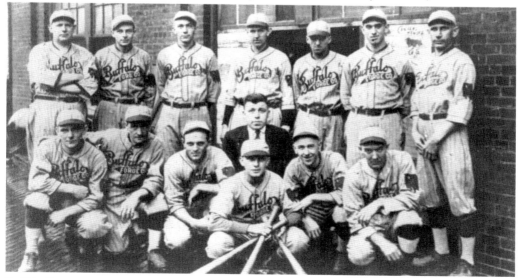

Buffalo Forge was an iconic local business for over 100 years. Beginning in 1878 as a manufacturer of portable blacksmithing forges, the company branched out and began to manufacture blacksmith drills, steam engines, and steam pumps. During its heyday, Buffalo Forge was one of Buffalo's largest employers. The original main building was at 490 Broadway Street. Here is the 1923 Industrial Champions League–winning team. Buffalo Forge closed in 1993. (Courtesy of the Buffalo History Museum.)

The Buffalo Bond Plant team poses for an undated photograph. Buffalo Bond Plant was a division of the original Pierce Steam Heating Company, which was founded in Buffalo in 1881 by John Pierce and Joseph Bond. Joseph Bond went on to become a part of the American Radiator Company when Pierce Steam Heating merged with other radiator companies to form this large conglomerate in 1892. (Courtesy of the Buffalo History Museum.)

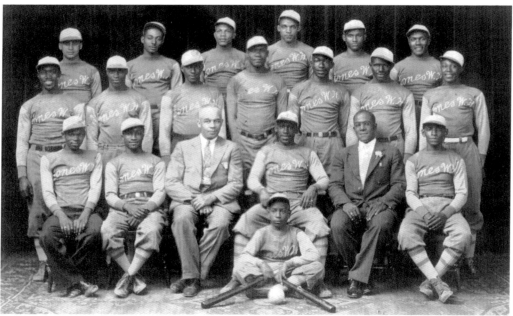

This 1929 W.H. Jones team was sponsored by a prominent African American Buffalonian, Wardner H. Jones, an undertaker located at 453 Jefferson Street. All of the players were Urban League and Michigan Avenue YMCA members. From left to right are (first row) Lonnie "Smitty" Brown, George Sarsnet, King Peoples, Wardner Jones, "Snow" Davis, and ball-boy Leland Jones; (second row) John Savage, Eddie Carter, John Rainey, Hank Williams, Leroy Duncan, unidentified, and Hueris Williams; (third row) "Ninny" Baker, Walter Harston, Clyde "Chicago" Bess, Charles McGarrah, and Walter Echols. (Courtesy of the Buffalo History Museum.)

FOR THE LOVE OF THE GAME

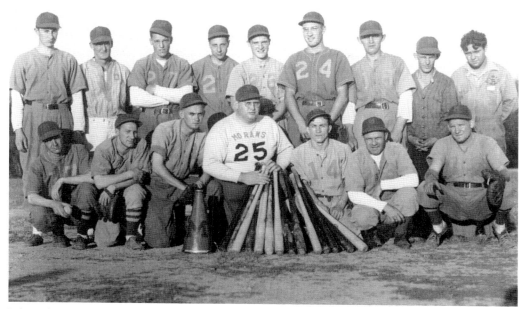

Like other Buffalo companies of the day, Morans Transportation Line fielded a team. Morans Transportation shipped automobiles. It was located at 22 Roseville Street, in southeast Buffalo near Larkin and Exchange Streets. This photograph is from 1935. (Courtesy of the Buffalo History Museum.)

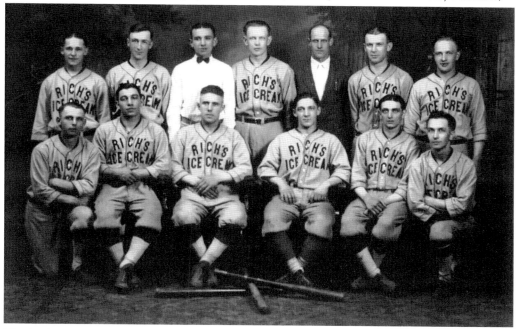

The Rich's Ice Cream team poses in the 1940s. Rich's Ice Cream was produced by Rich Products of Buffalo, located near the intersection of West Ferry and Niagara Streets. In 1983, Robert Rich Jr. became the owner of the Buffalo Bisons. (From the John Boutet Collection.)

In this 1965 photograph, teammates Tovie Asarese (left) and Nick Mitre of the Royal Printing team share a smile for the camera. Buffalo's baseball history includes many corporate teams. Royal Printing has been in business on Buffalo's west side since 1953. Tovie Asarese was inducted into the Greater Buffalo Sports Hall of Fame in 2007. (Courtesy of the Buffalo History Museum.)

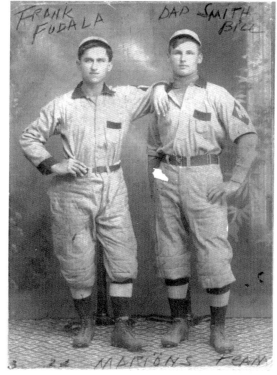

Based on the uniforms, this undated photograph appears to be from the early 20th century. "Marions Team" may refer to a town ball team that played in Marion, New York, 20 miles east of Rochester. Town ball was a popular pastime in smaller communities, where the "game of the week" would not feature the New York Yankees and the Boston Red Sox but the local nine who gathered on the diamond and played for town pride against nearby towns. (Courtesy of the Buffalo History Museum.)

FOR THE LOVE OF THE GAME

This 1905 photograph shows the boys' baseball team from Wanakah, New York. Wanakah is a hamlet in the town of Hamburg, about 10 miles south of Buffalo. (Courtesy of the Roy Nagel Collection, the Buffalo History Museum)

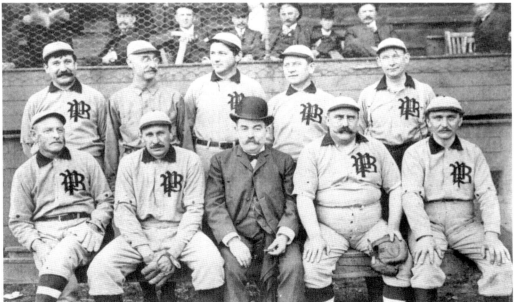

Early baseball teams encompassed all walks of life. Based on the caption for this 1905 photograph, the team was known as the Aldermen. It is unknown if this team was made of elected officials or individuals from a particular ward of the city. In the first row at center is Charles J. Fix, who was the alderman for the 15th Ward, in the Polish and Italian section of Buffalo. The boundaries of this ward were Main Street, Jefferson Avenue, East Delavan Avenue, and North Street. (Courtesy of the Buffalo History Museum.)

In 1908, the Gardenville Rattlers boys' team proudly poses for a photograph. Gardenville is a farming community in the town of West Seneca. (Courtesy of the Buffalo History Museum.)

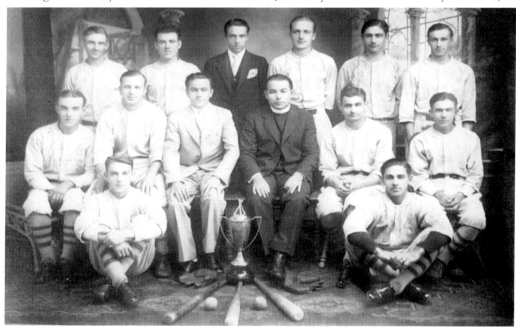

This c. 1930 photograph shows the St. Johns-Ukes team from the St. John the Baptist-Ruthenian Greek Church at 60 Hertle Avenue. This neighborhood in the Blackrock area was made up of Eastern Europeans, including Ukrainians and Poles. The church closed in 2007. From left to right are (first row) William Mydzian and Mike Mallas; (second row) Mike Mydzian, Joseph Guize, John Mallas, Fr. John Zuck, William Harwicz, and Joseph Mallas; (third row) Michael Mallas, Steven Lestition, Michael Pistak, Peter Guize, John Youra, and Julian Guize. This team was comprised of family members, including fathers, sons, and brothers. (Courtesy of the Buffalo History Museum.)

FOR THE LOVE OF THE GAME

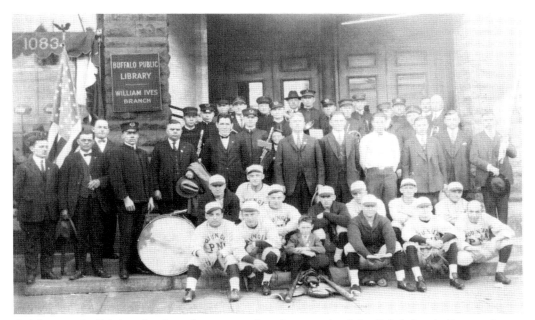

Celebrating Buffalo's rich ethnic heritage is this photograph of the Polish baseball team. It was taken in East Buffalo at 1079 Broadway, the location of the William Ives branch of the Buffalo and Erie County Public Library that also doubled as a Polish cultural center called Dom Polski. Not only are the baseball players present, but the Polish band is as well. (Courtesy of the Buffalo History Museum.)

In a city filled with hometown pride, community, and heritage, baseball is the common joy amongst all nationalities. Here, in 1978, the Puerto Rican community celebrates its ethnicity and its love of baseball. (Courtesy of the Buffalo History Museum.)

In 1934, Delaware Park League president Jane Lear shows her best swing while wearing heels. The catcher is team sponsor Gerald K. Rudolph. This event was for the opening ceremonies of the Delaware Park League. These leagues have been a staple of Buffalo baseball for three quarters of a century. (Courtesy of the Buffalo History Museum.)

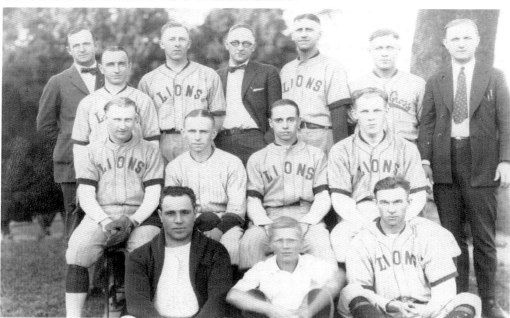

The Lions team poses for an undated photograph. It is unknown what Lions club of Western New York this team played for. The Lions are an organization of over 1.4 million members worldwide, well known for their work with visual, hearing, and speech impaired individuals. (Courtesy of the Buffalo History Museum.)

FOR THE LOVE OF THE GAME

Central High School, in downtown Buffalo in Niagara Square, was Buffalo's only high school until 1897. The school was in existence from 1854 to 1914. In 1926, it was demolished to build what is now the Mahoney Office Building. In these undated photographs, the boys' baseball team is seen. (Both, courtesy of the Buffalo History Museum.)

The Masten Park High School boys pose for their team photograph in 1928. This school is on the corner of Masten Avenue and East North Street. The original school building was constructed in 1912–1914 and is listed in the National Register of Historic Places. The site was an early-19th-century potter's field. As recently as 2007, human remains have been found on the site. The school is now named City Honors School. (Courtesy of the Buffalo History Museum.)

FOR THE LOVE OF THE GAME

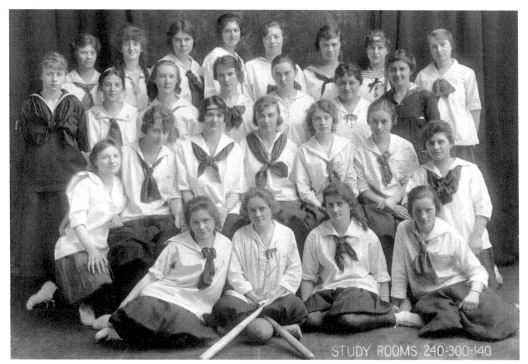

Founded in 1904 as Mechanic Arts High School, Hutchinson Technical High School or "Hutch-Tech" is a Buffalo public school on Elmwood Avenue with a rich history of sports and baseball. In this undated photograph, the girls' team is using a larger 16-inch softball. Sometimes called "mushball" or "cabbageball," this game became popular in Chicago and spread from there. The rules are the same for standard softball, with one notable exception: the fielders do not use gloves. The boys' team below is from the same school. (Both, courtesy of the Buffalo History Museum.)

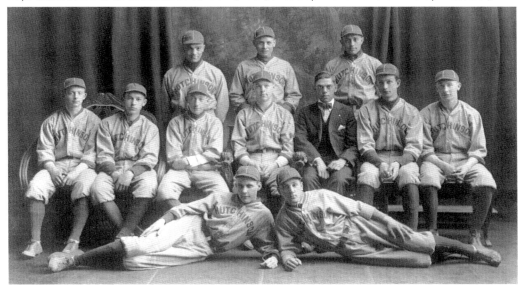

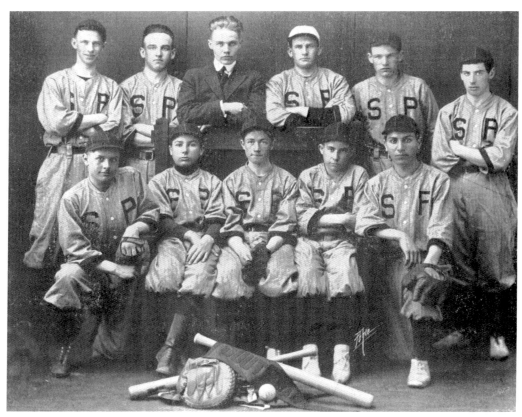

This 1915 photograph shows one of the first baseball teams from South Park High School. The school is located at 150 Southside Parkway. (Courtesy of South Park High School.)

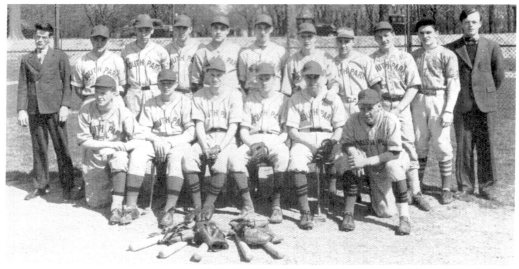

South Park High School's 1939 yearbook features the boy's baseball team. Future hall of famer Warren Spahn (back row center) is pictured with his teammates. (Courtesy of South Park High School.)

FOR THE LOVE OF THE GAME

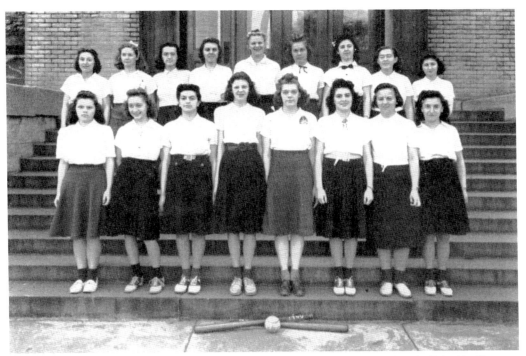

This yearbook photograph shows the 1940 South Park High School girls' baseball (softball) team. (Courtesy of South Park High School.)

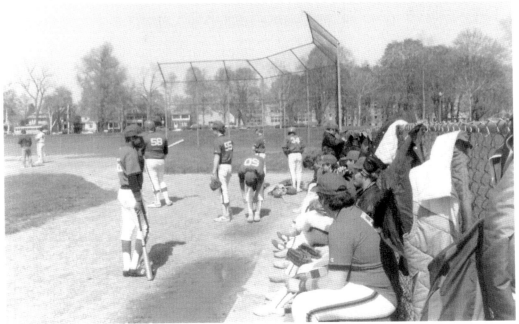

In this undated photograph, the South Park High School boys' baseball team prepares for a game. (Courtesy of South Park High School.)

This late 1980s photograph shows the girls' softball team for South Park High School. (Courtesy of South Park High School.)

This photograph is from the 1979 Georgetown Cup championship and shows St. Joe's Collegiate Institute. St. Joe's finished with a record of 20-1 and won the championship. Kneeling in the first row on the far left is shortstop–second baseman John Boutet (wearing eye black), who was inducted into the St. Joe's Hall of Fame in 2011. In the back row on the far left is center fielder–pitcher Chris Rehbaum, who was cast for a role in 1984's *The Natural*. The team was inducted into the St. Joe's Hall of Fame in 2015. (From the John Boutet Collection.)

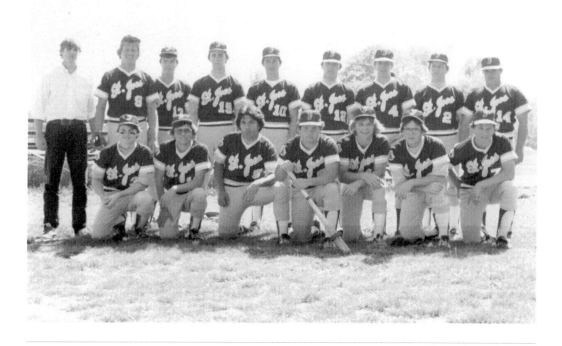

FOR THE LOVE OF THE GAME

This c. 1900 jersey is for the Niagara Purple Eagles collegiate team from Niagara University in Lewiston, New York. (From the John Boutet Collection.)

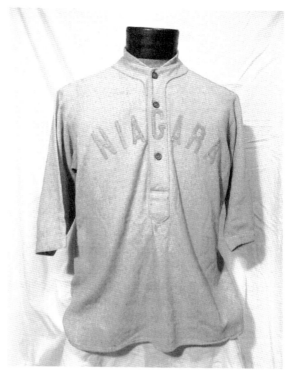

The old game of pepper is demonstrated at its finest here by the University of Buffalo baseball team in May 1973. The team was practicing for the NCAA District 2 tournament against Temple University. Pictured are pitcher Jim Niewczyk throwing the ball, Joe Piscotty with the bat, Dan Gorman (left of Niewczyk), and Mike Klym (right of Niewczyk). (Courtesy of *Courier-Express* Baseball Series Images: Archives & Special Collections Department, E.H. Butler Library, SUNY Buffalo State.)

Schiller Park, located in Buffalo on the border of Cheektowaga at East Delavan Avenue and Genesee, has always been a popular place for amateur-league baseball. This April 19, 1968, photograph of the High School Monsignor Martin Catholic League shows that even amateurs like Turner third baseman Mike Vanderlip are able to make acrobatic plays when playing America's pastime. (Courtesy of the Buffalo History Museum.)

Delaware Park is the crown jewel of the Buffalo park system and was designed by Frederick Law Olmsted. Located on Buffalo's north and east sides, it is one of the most popular places for amateur baseball in the entire city. In this 1967 photograph, Don Colpoys from the Simons team waits for his pitch from Dan Lyles of the Nowaks team. The second half of the battery is Jim Grelick, and Jerry Stockman looks on, calling balls and strikes. This is the Municipal Baseball League, one of the top amateur leagues in the Buffalo area. (Courtesy of the Buffalo History Museum.)

FOR THE LOVE OF THE GAME

ABOUT THE ORGANIZATION AND CONTRIBUTOR

THE BUFFALO HISTORY MUSEUM

Founded in 1862, The Buffalo History Museum is incorporated as a private, nonprofit, tax-exempt organization under Section 501(c)(3) of the Internal Revenue Code. It receives operating support from the County of Erie, the City of Buffalo, the New York State Council on the Arts, and members and friends. The Buffalo History Museum is accredited by the American Alliance of Museums. From handwritten business ledgers to innovations marking industries and from folders of neighborhood photographs to complete soldiers' footlockers, the Buffalo History Museum safeguards a vast array of treasures. Today, more than 100,000 physical objects, over 200,000 photographs, and over 25,000 books and manuscripts mark time and shape our understanding of Western New York. Westward expansion, industrialization, immigration, transportation, presidential, military, and social history—these themes tie us to our nation's story.

Native Western New Yorker John Boutet is the official archivist and curator for the AAA Buffalo Bisons as well as the site and exhibit chairman for the Greater Buffalo Sports Hall of Fame. John played baseball at Canisius College and St. Joseph's Collegiate Institute, where he was inducted into the Athletic Hall of Fame in 2011. He was also inducted into the Western New York Baseball Hall of Fame the same year. In addition to his world-class Buffalo sports memorabilia collection, John has contributed to books on the Buffalo Sabres, the Buffalo Braves, and Memorial Auditorium. He also has contributed to Buffalo sports stories on ESPN and local television. In 2012, he led the drive to erect a historical plaque on the site of Offermann Stadium. He has bachelor's and master's degrees from Canisius College and is employed as a physical education teacher and coach in the Niagara Wheatfield Central School District.

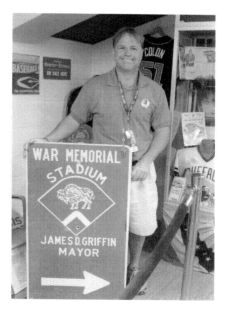

Discover Thousands of Local History Books
Featuring Millions of Vintage Images

Arcadia Publishing, the leading local history publisher in the United States, is committed to making history accessible and meaningful through publishing books that celebrate and preserve the heritage of America's people and places.

Find more books like this at
www.arcadiapublishing.com

Search for your hometown history, your old stomping grounds, and even your favorite sports team.